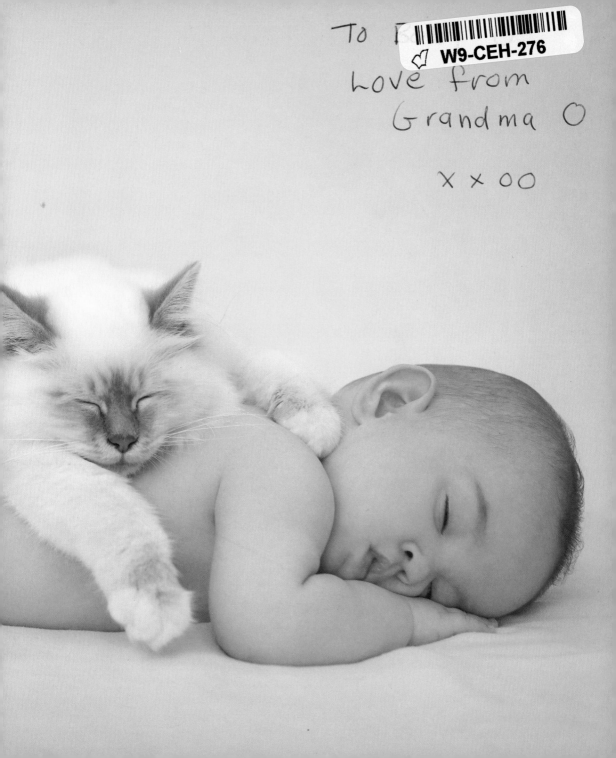

To
Love from
Grandma O

X X OO

best
friends
forever

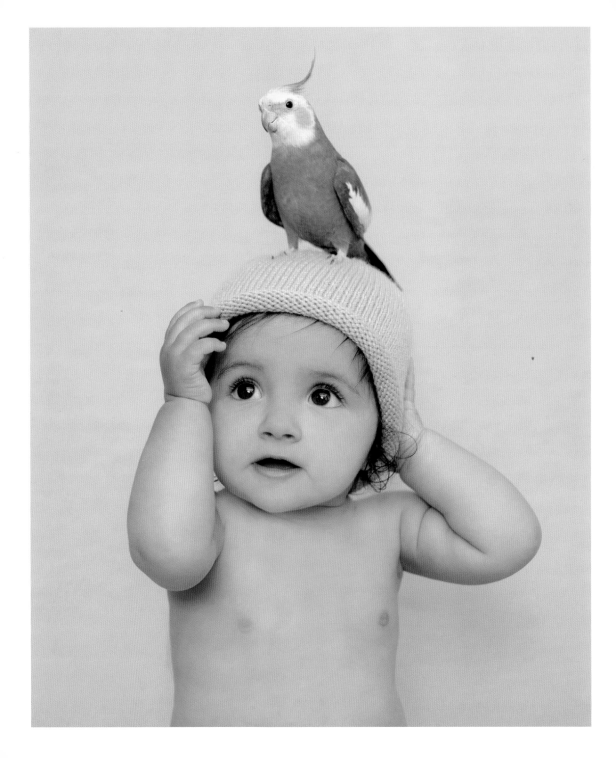

best friends forever

Photographs by
Rachael Hale McKenna

CHRONICLE BOOKS

SAN FRANCISCO

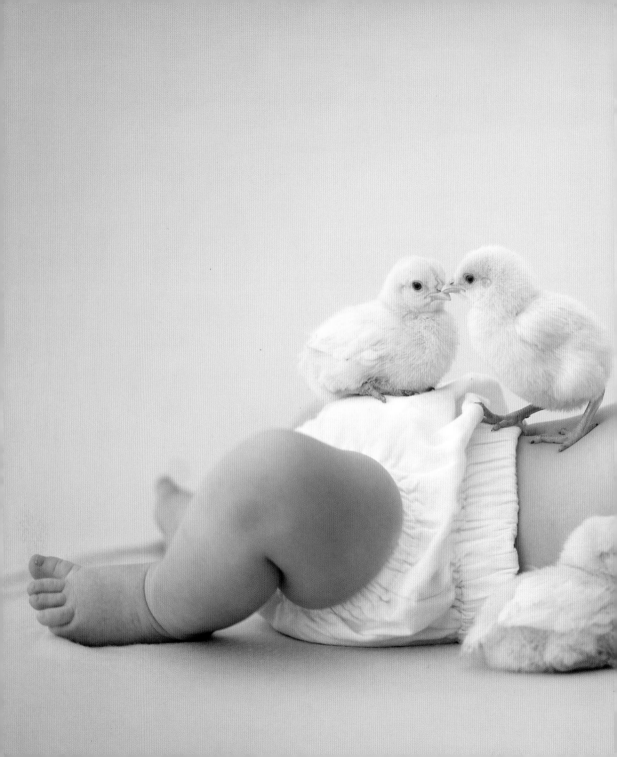

"A true friend is someone who
thinks that you are a good egg . . .

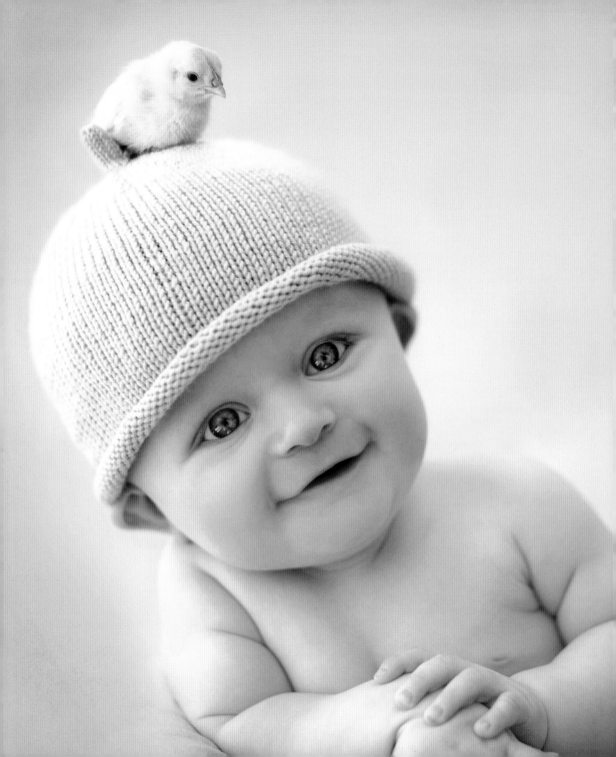

. . . even though he knows that
you are slightly cracked."

—BERNARD MELTZER

A friend is someone who . . .

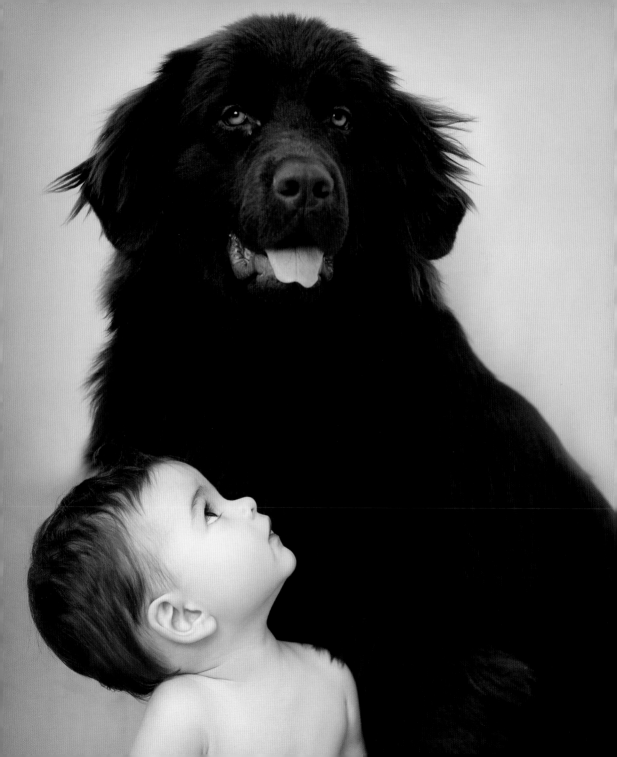

. . . reaches out for your hand and

touches your heart.

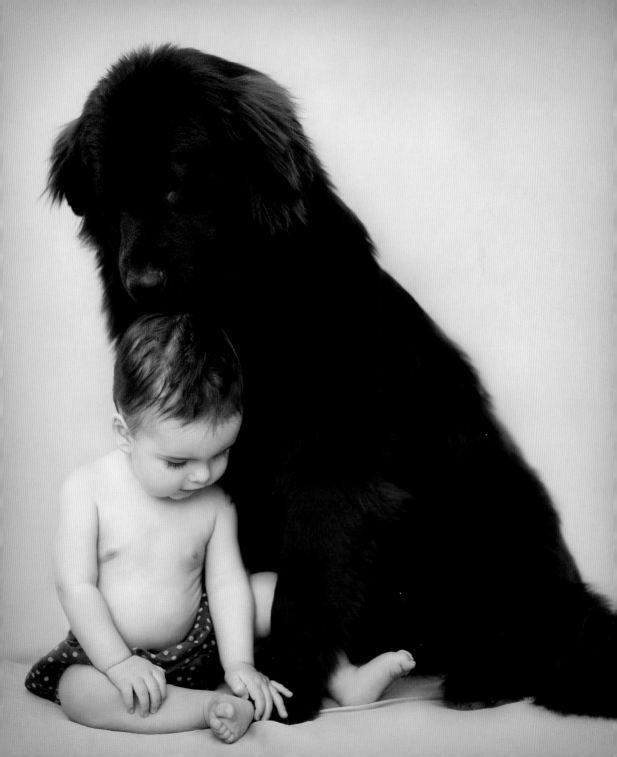

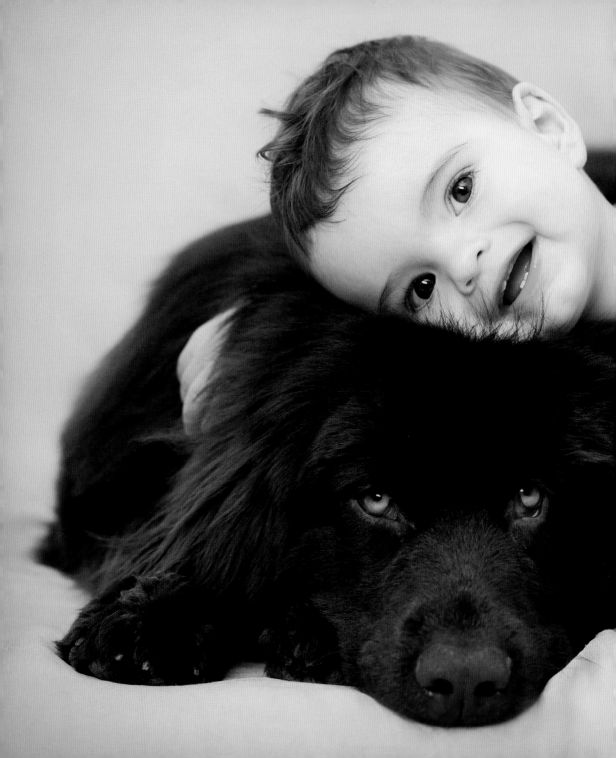

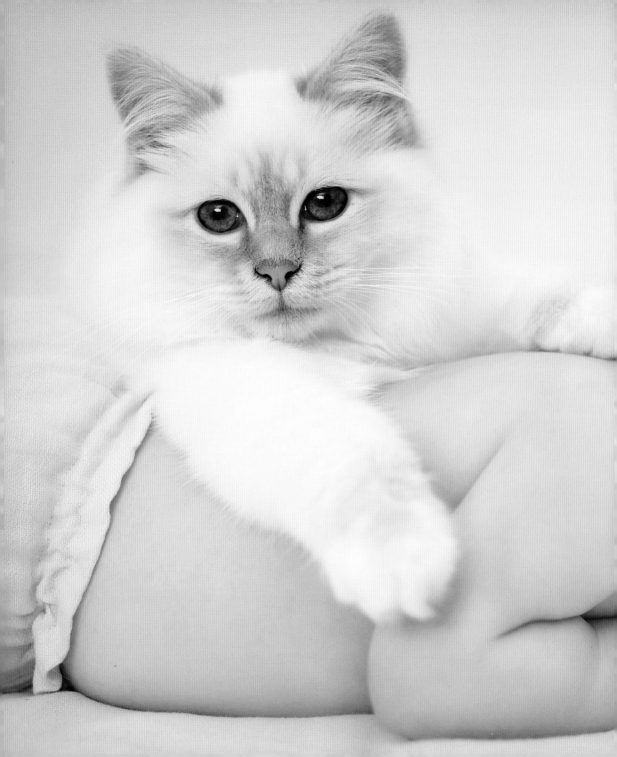

Friendship isn't a big thing . . .

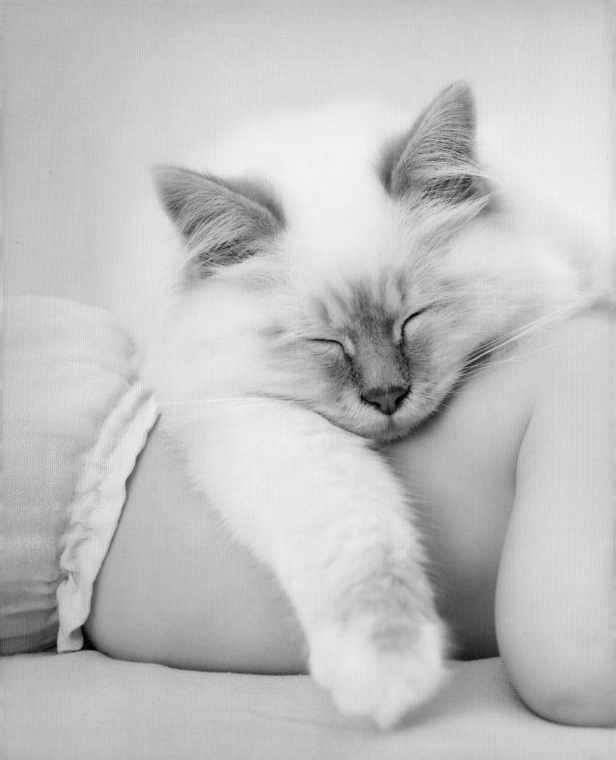

. . . it's a million little things.

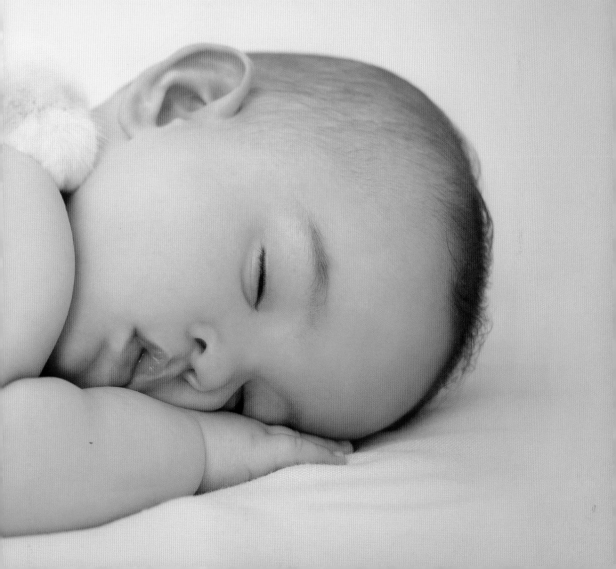

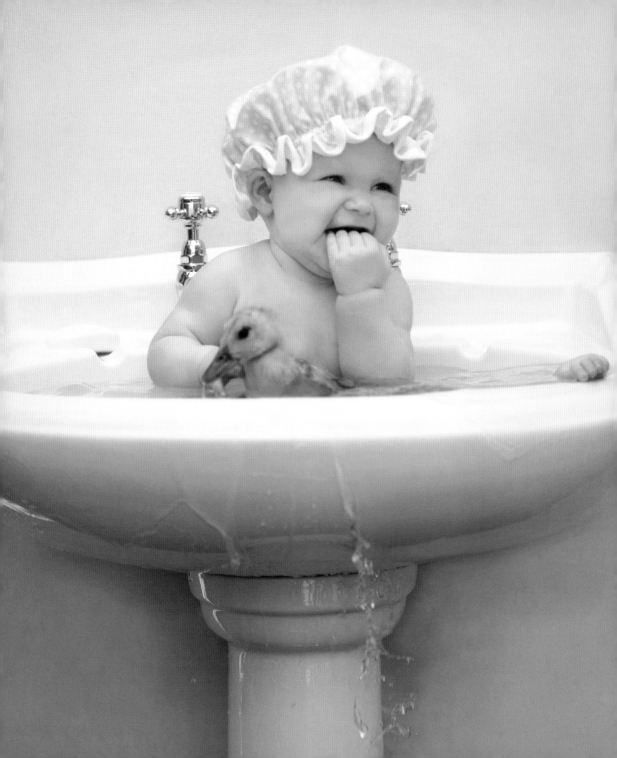

"The most

beautiful discovery

is that . . .

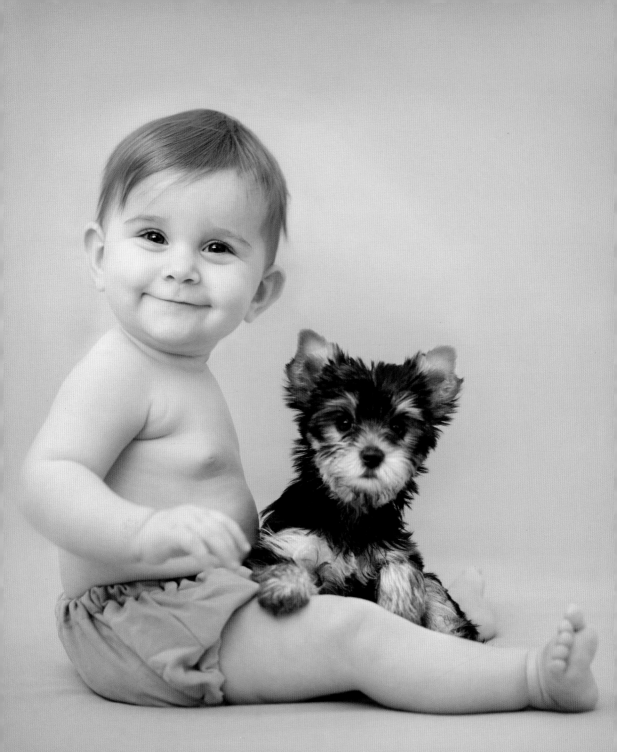

. . . true friends grow separately
without growing apart."

—SYDNEY SMITH

Whenever I think of you,

it makes me smile.

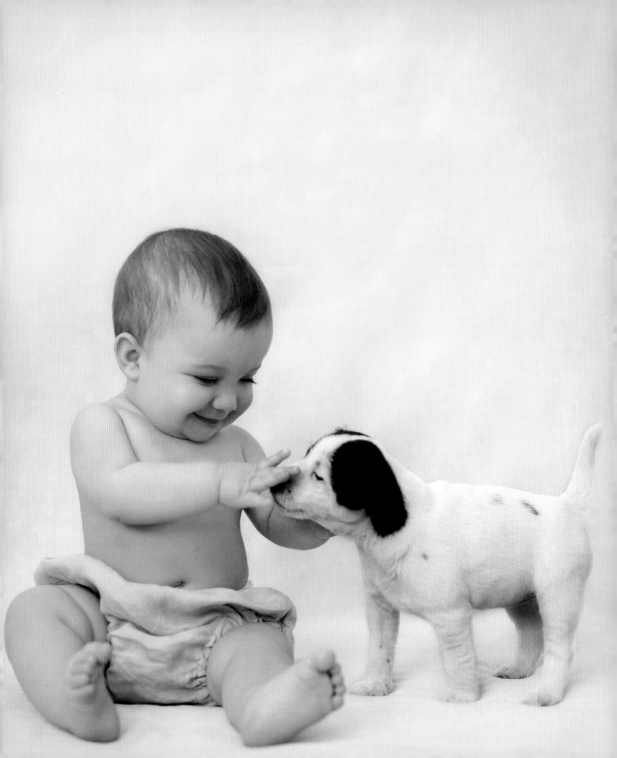

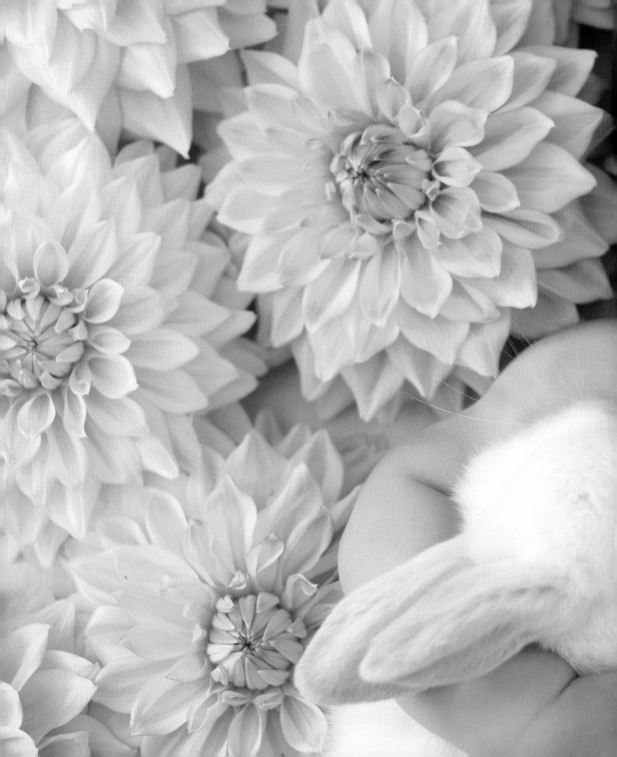

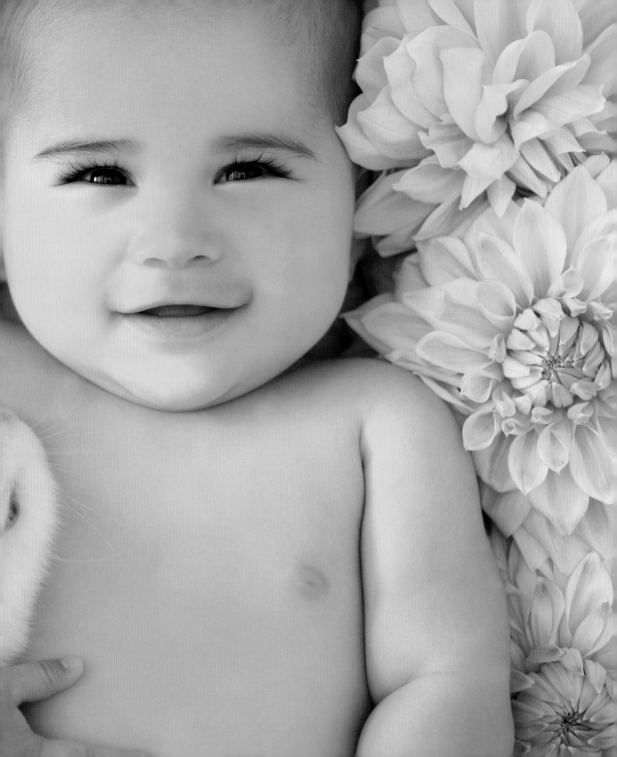

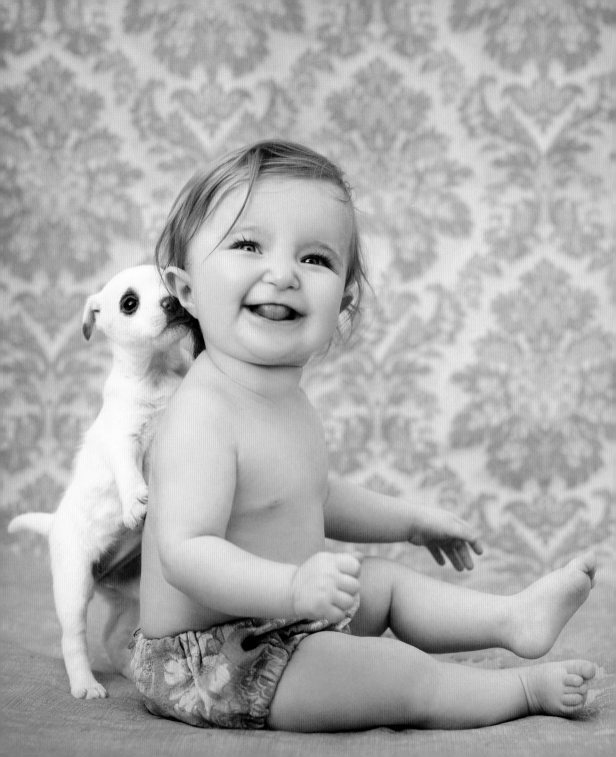

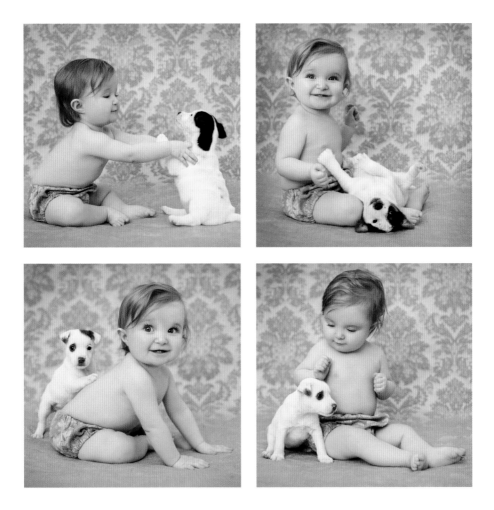

Just thinking about
a friend makes you want to do

a happy dance.

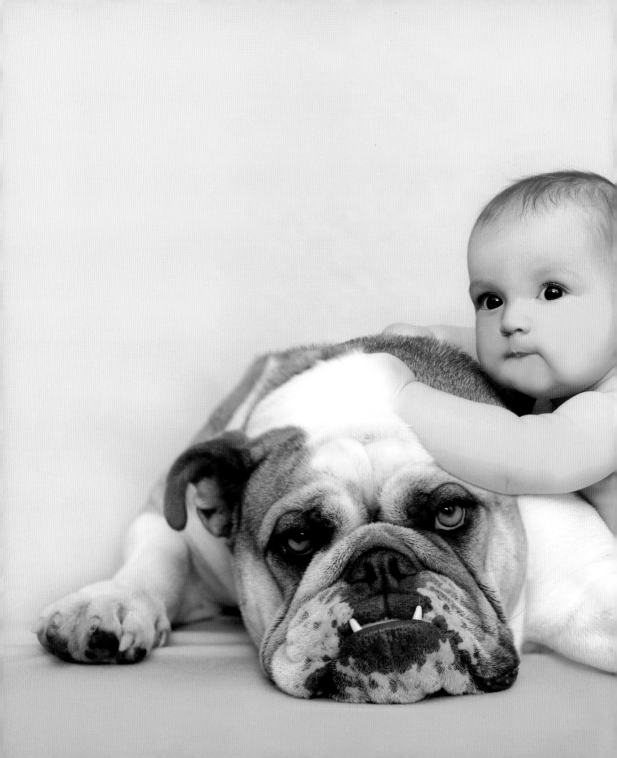

"Only your real friends . . .

. . . will tell you when your face is dirty."

—SICILIAN PROVERB

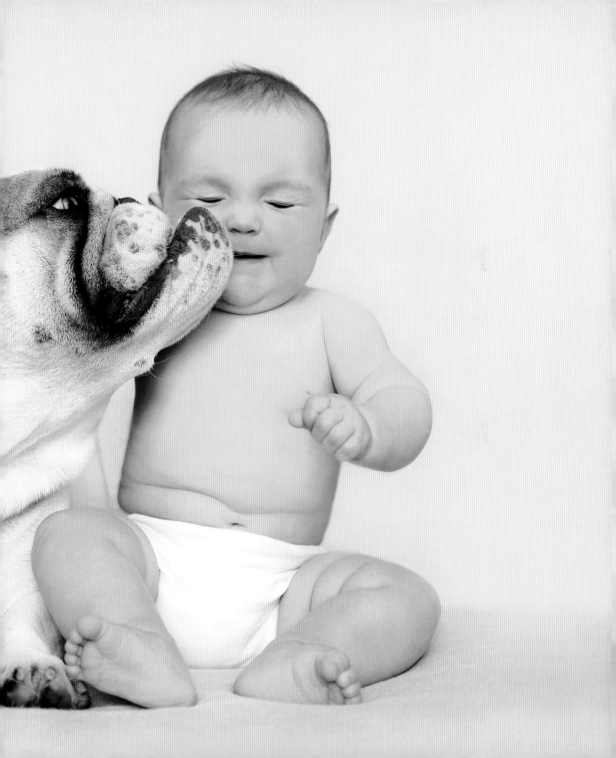

"A friend is one of the nicest
things you can have, and one of the
best things you can be."

—DOUGLAS PAGELS

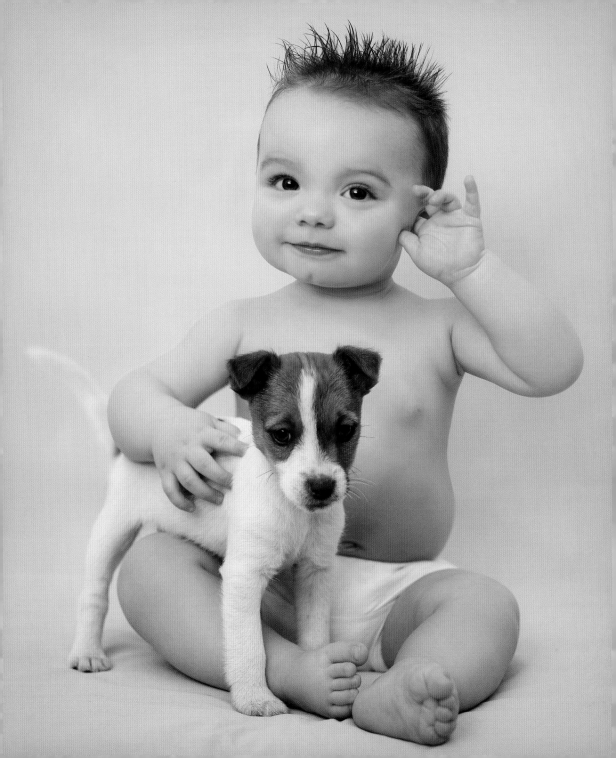

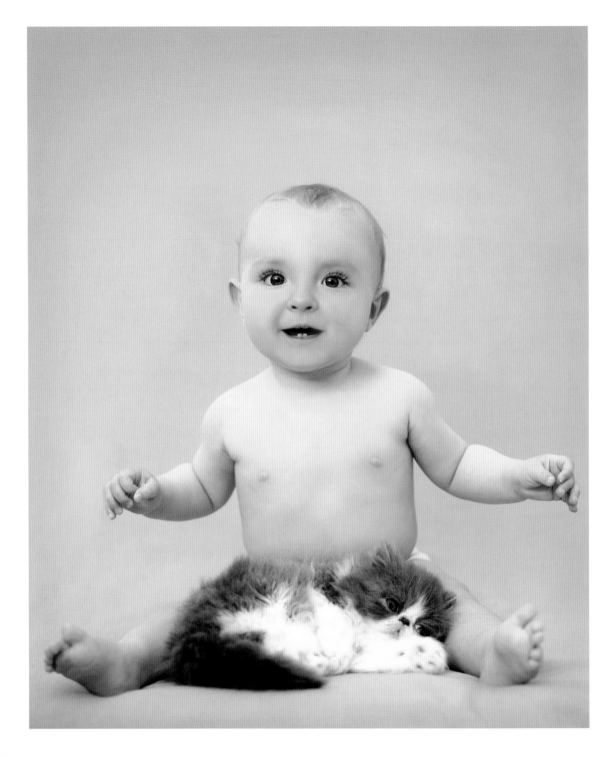

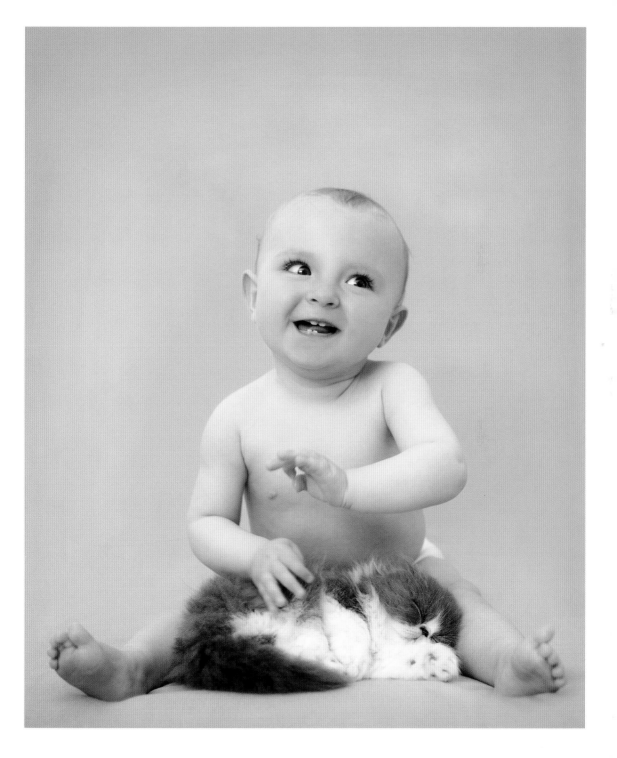

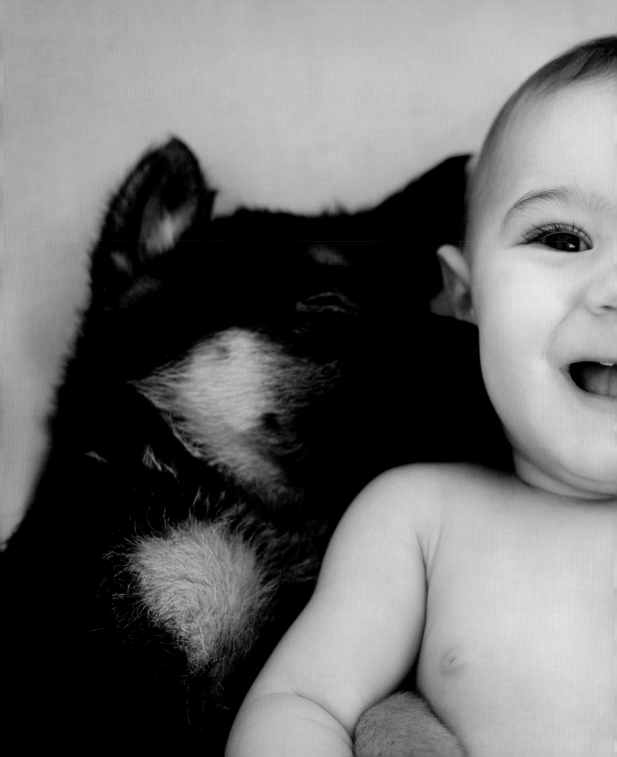

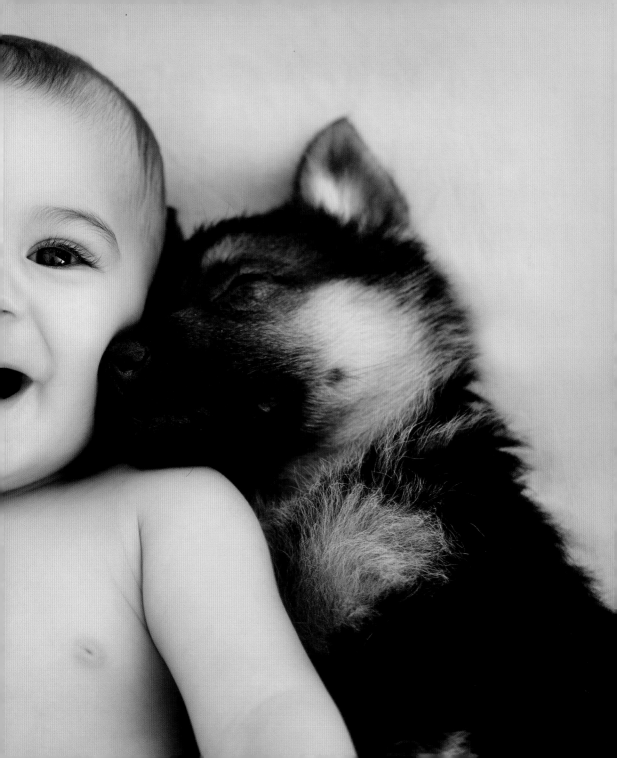

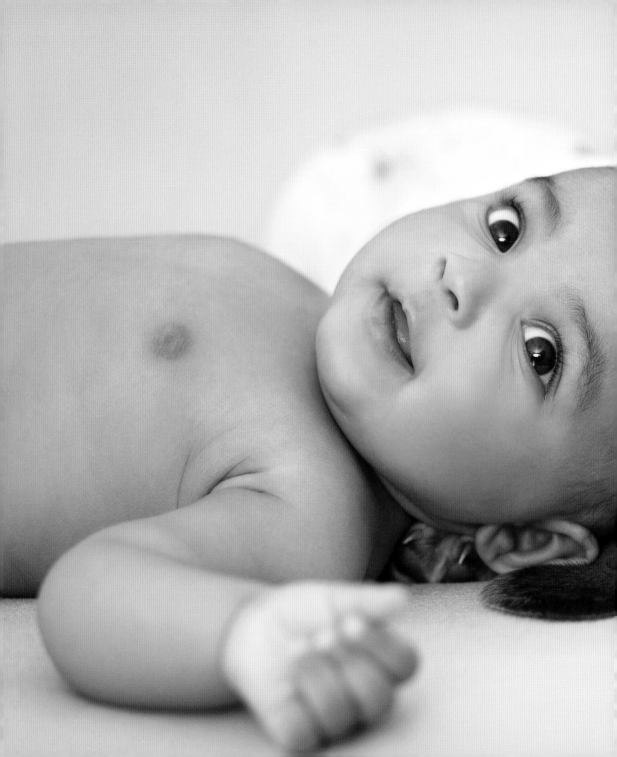

A friend is someone
you can lean on.

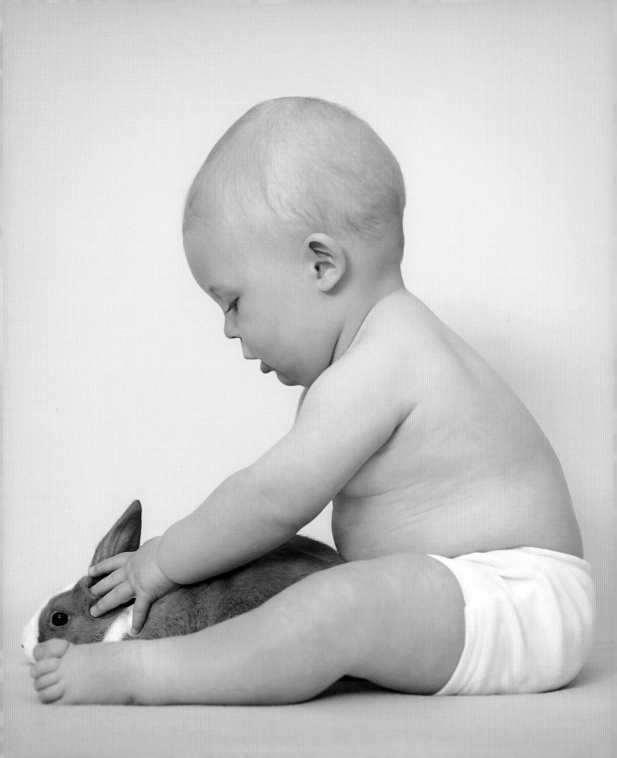

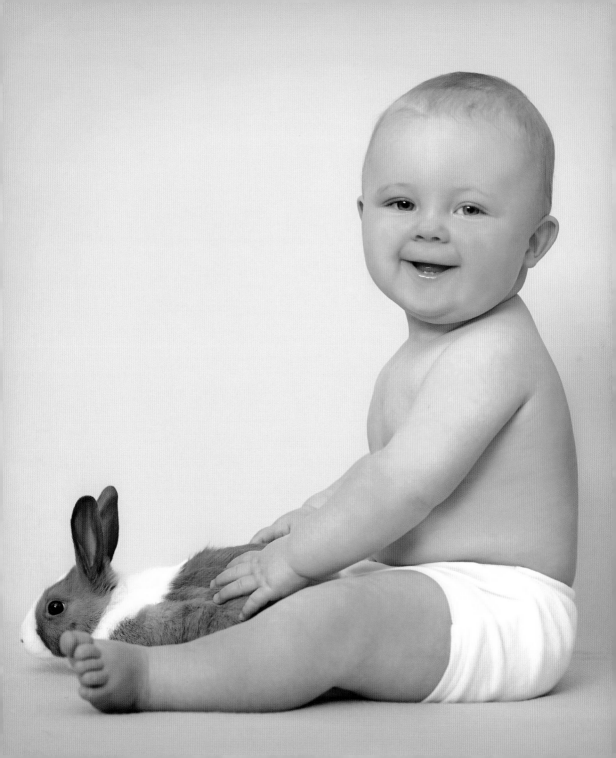

"Hold a true friend
with both hands."

—NIGERIAN PROVERB

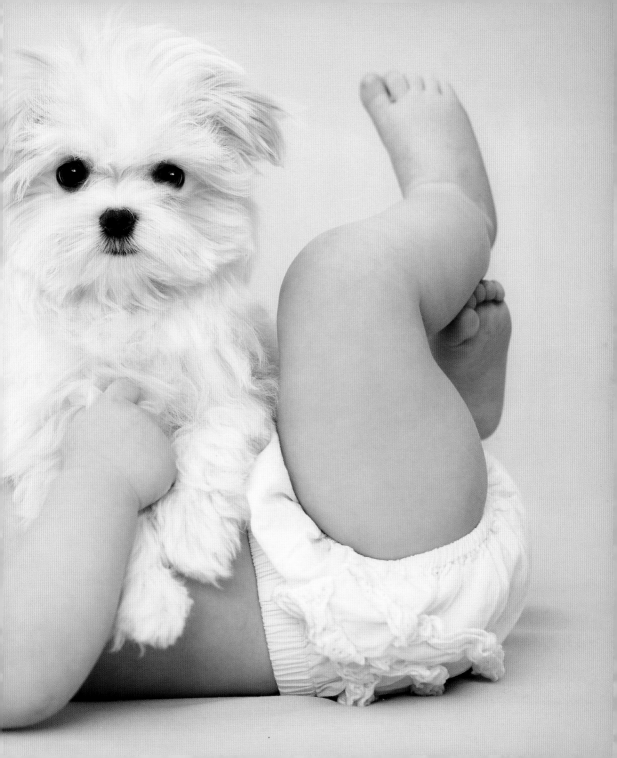

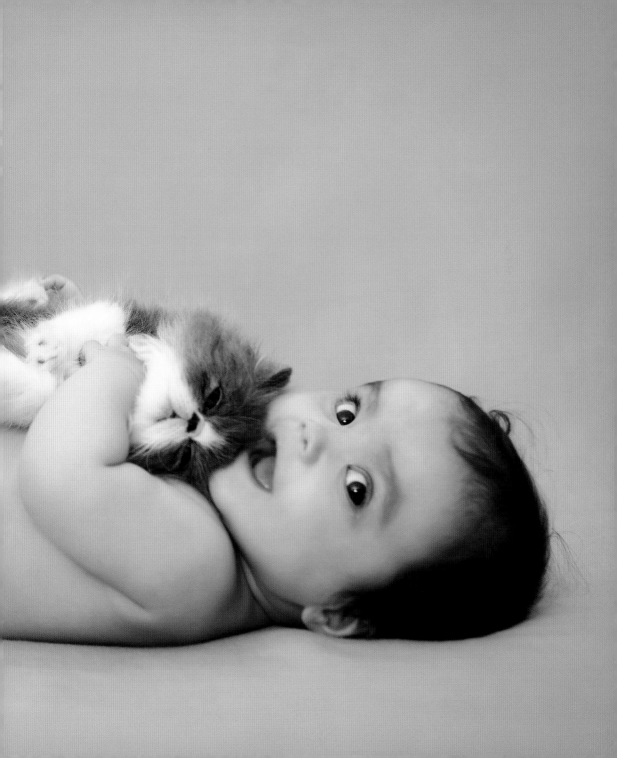

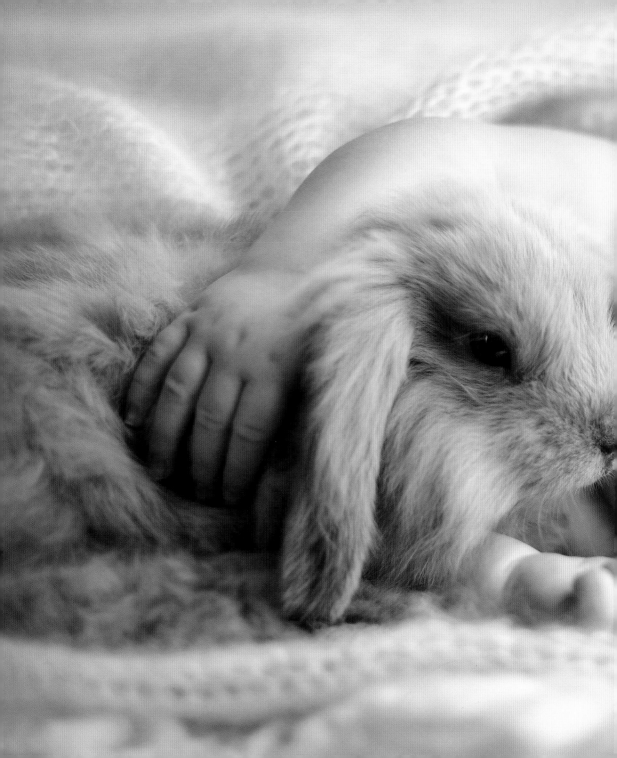

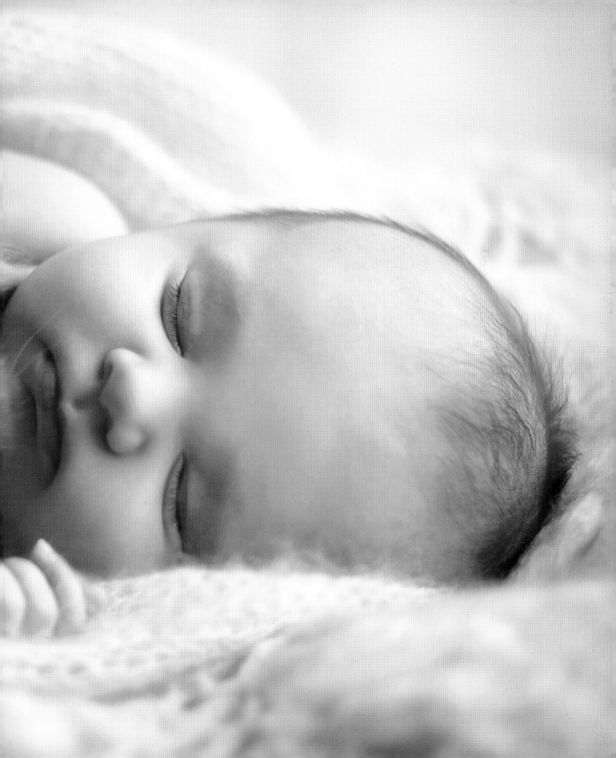

"There's nothing better
than a good friend . . .

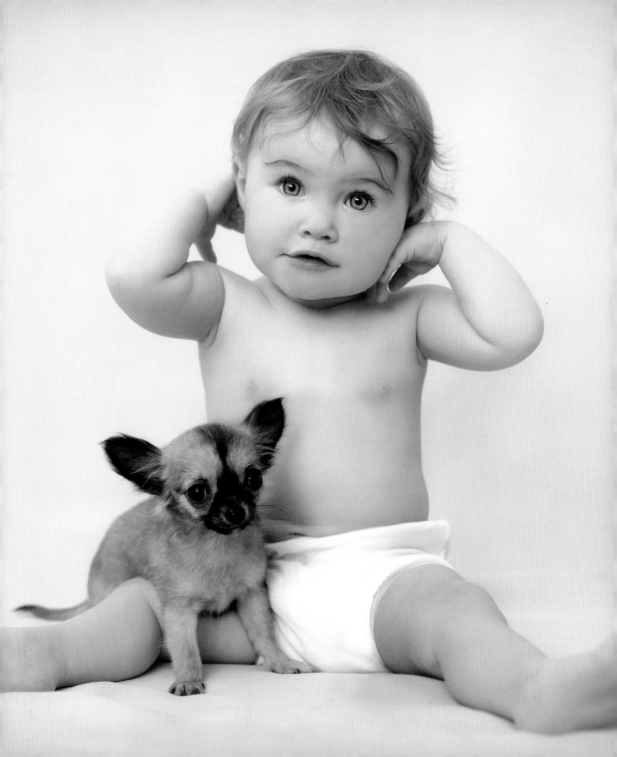

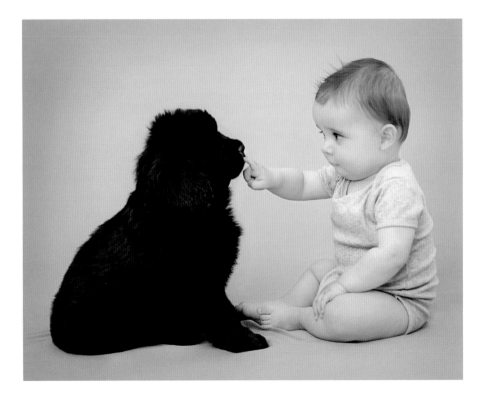

. . . except a good friend . . .

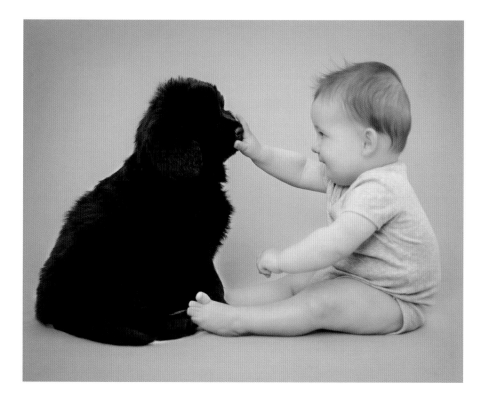

. . . with chocolate."

—LINDA GRAYSON

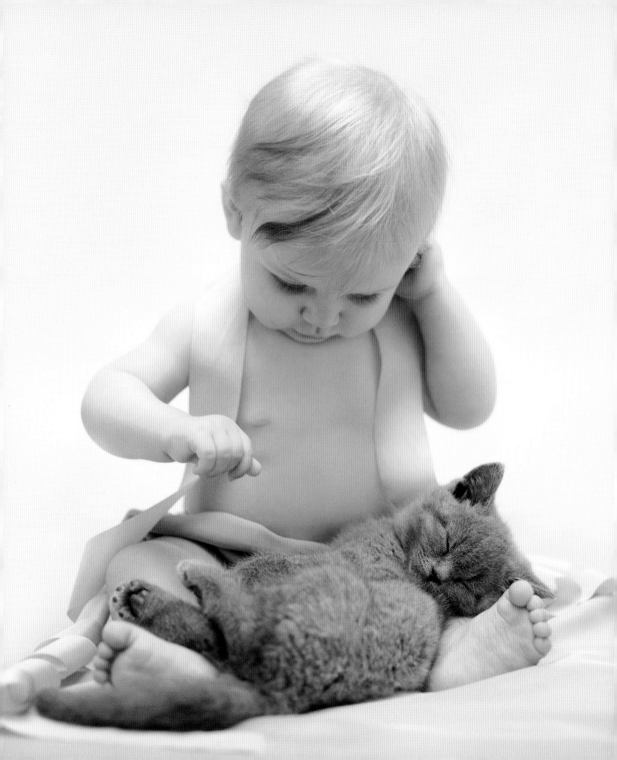

The better you know someone,

the less there is to say.

Or maybe, there's less that needs to be said.

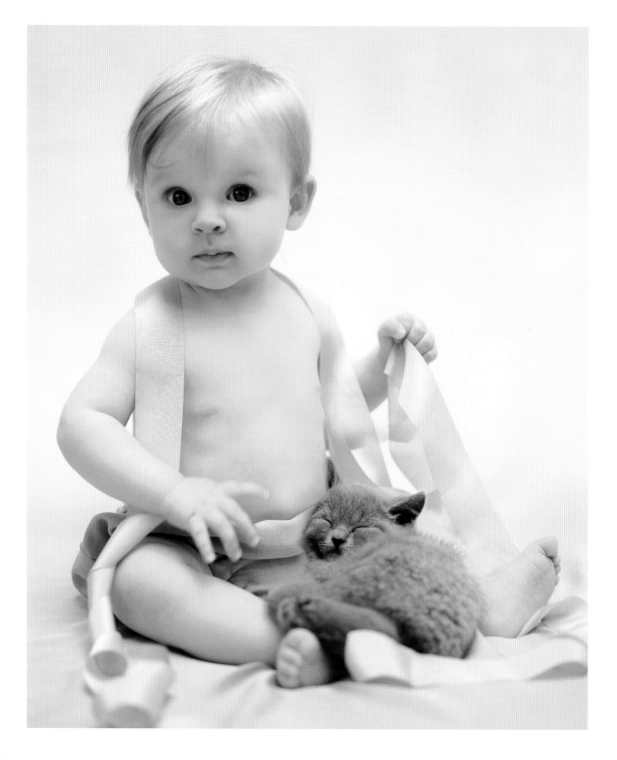

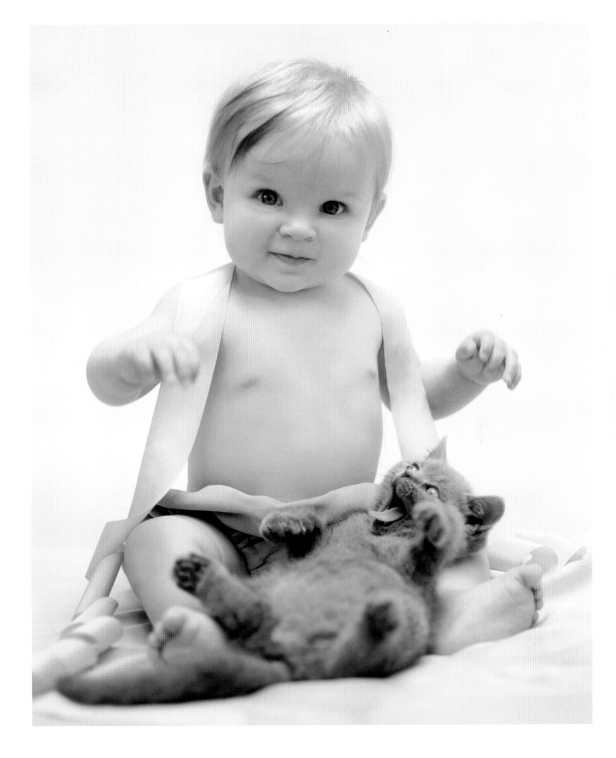

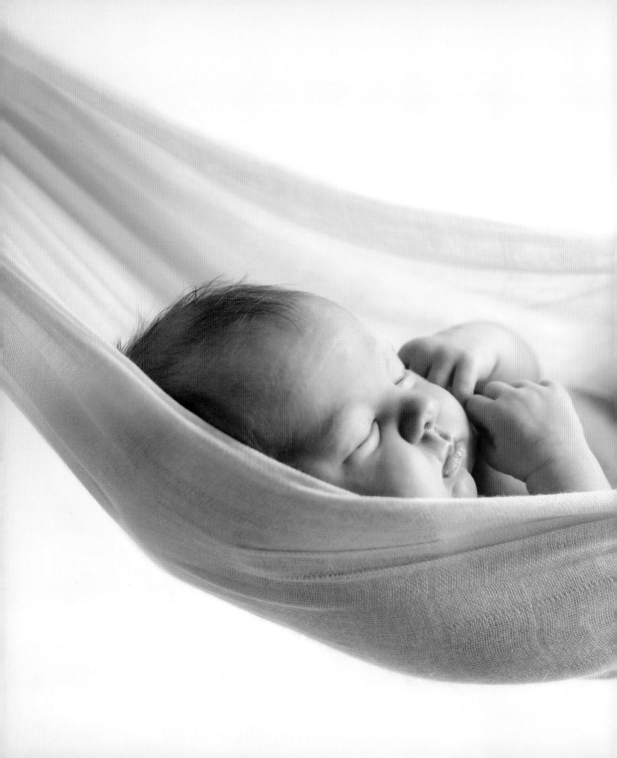

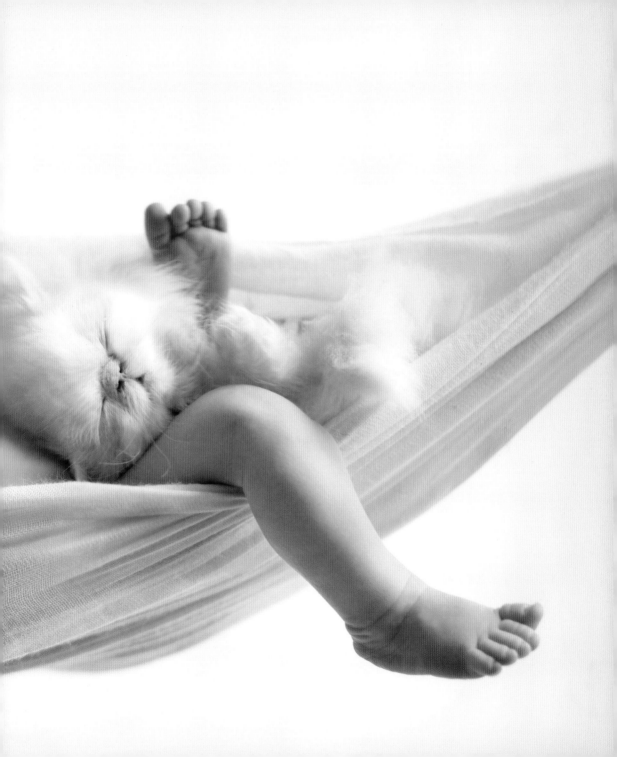

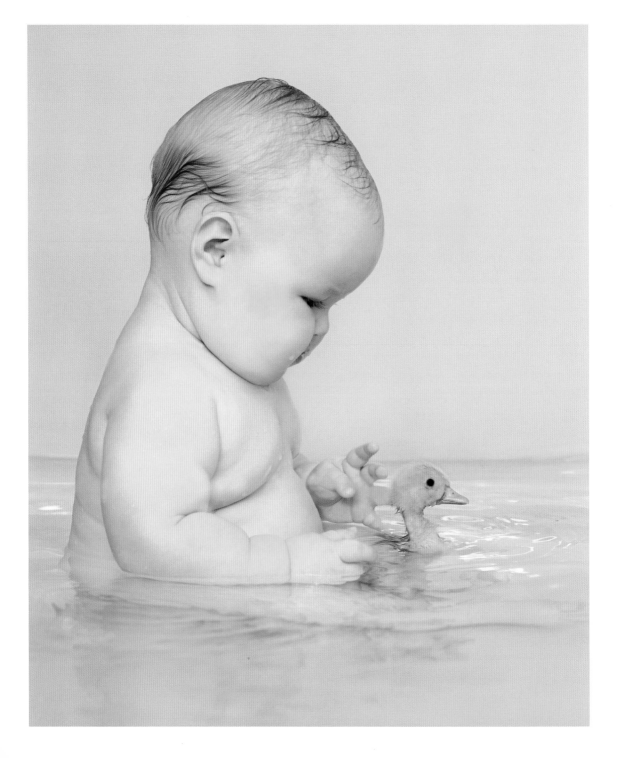

To love and to be loved is

the greatest happiness

of existence.

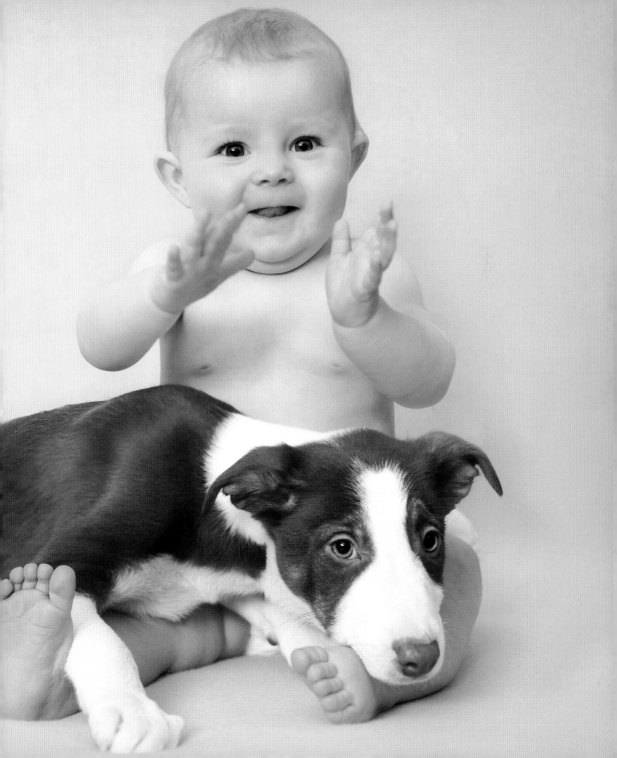

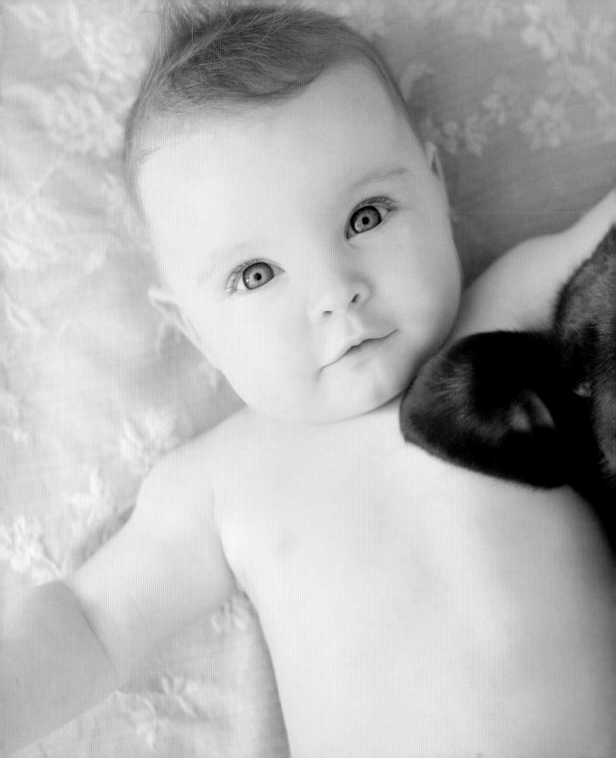

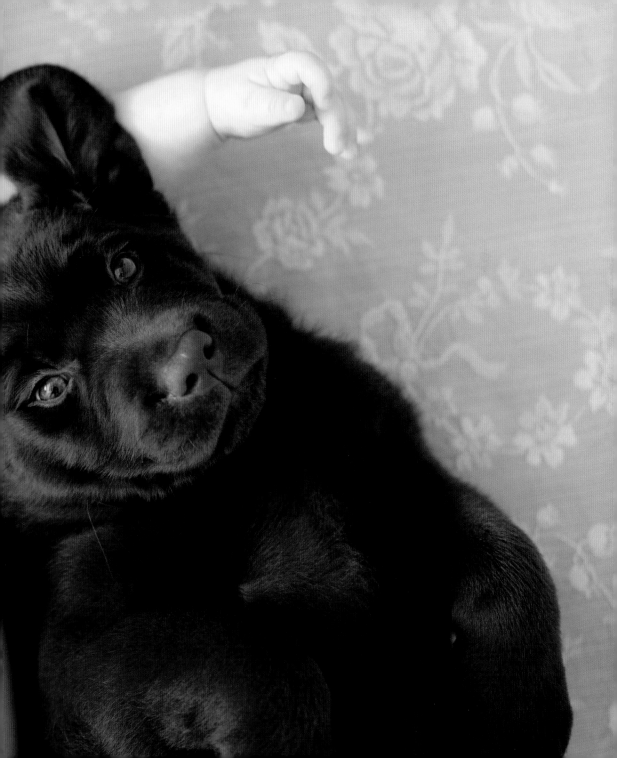

Together

is the best place to be.

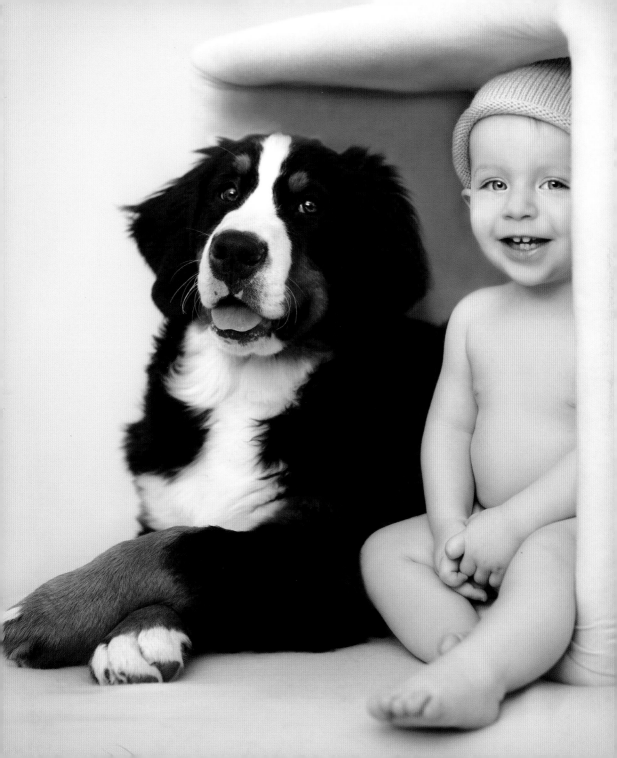

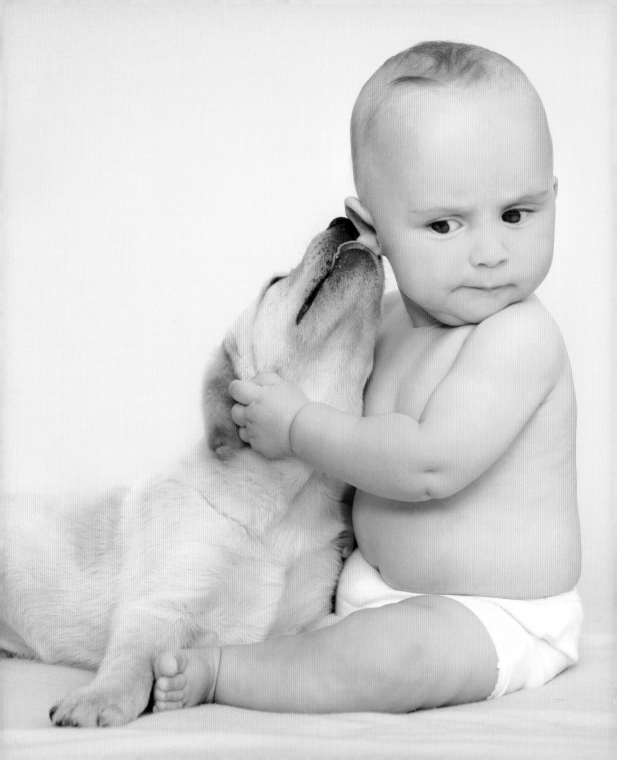

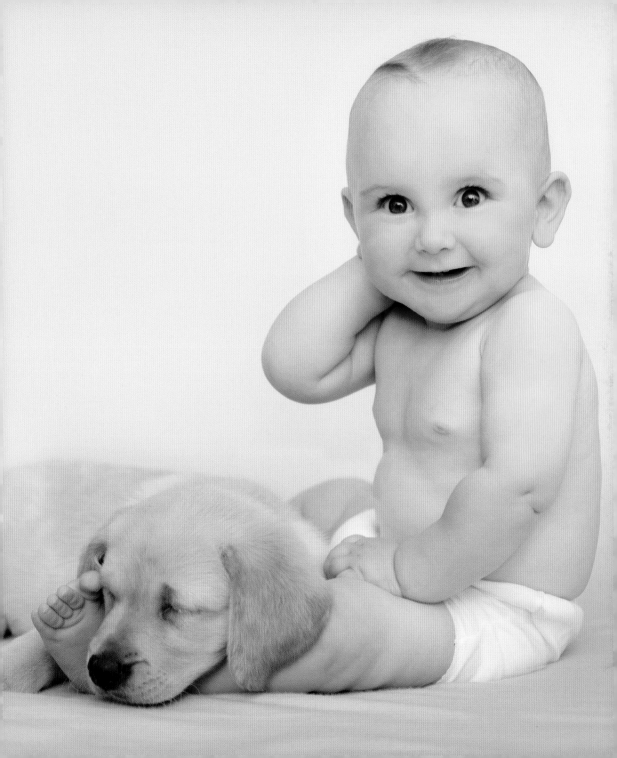

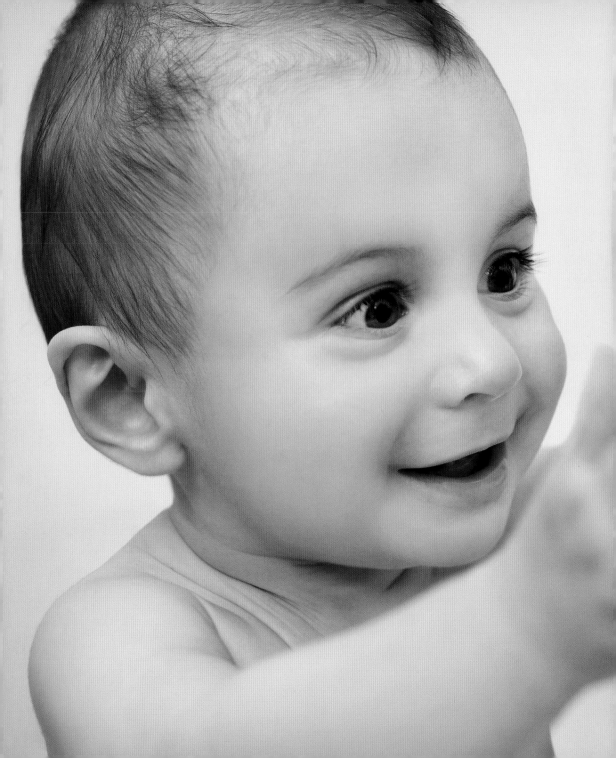

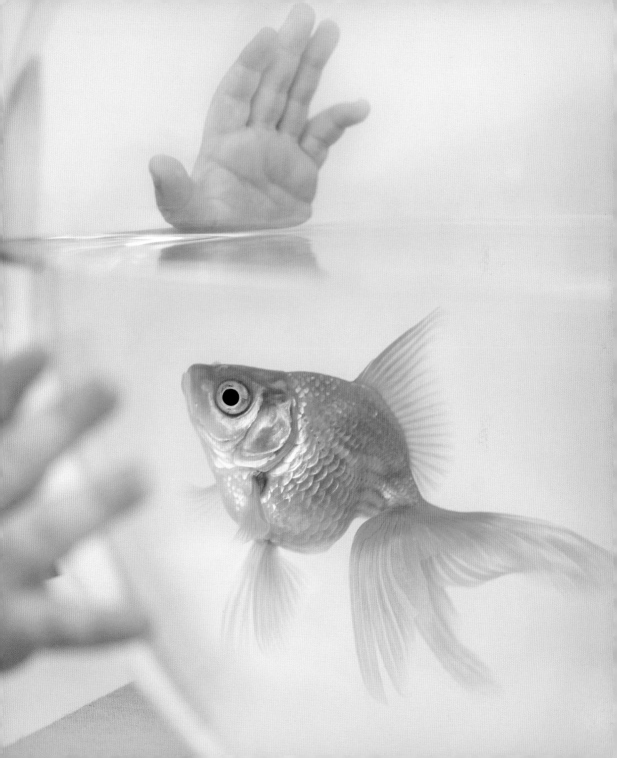

"Who finds a
faithful friend,
finds a treasure."

—JEWISH SAYING

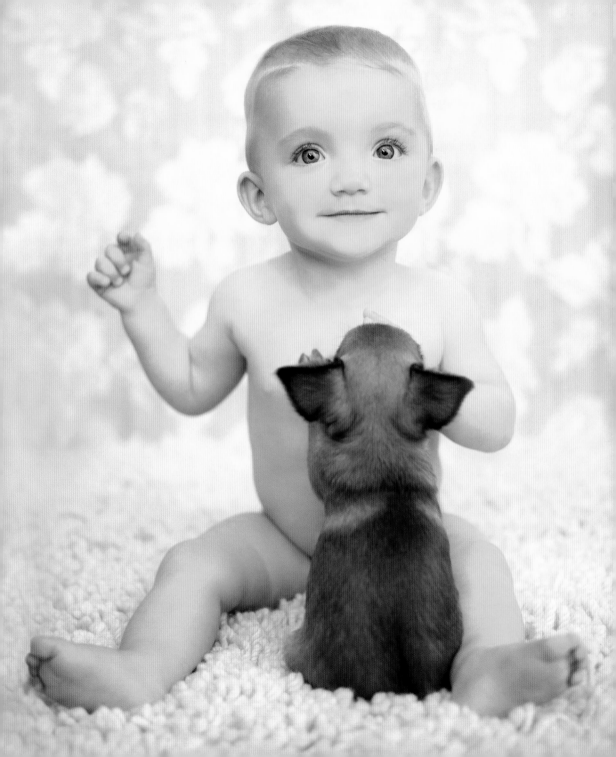

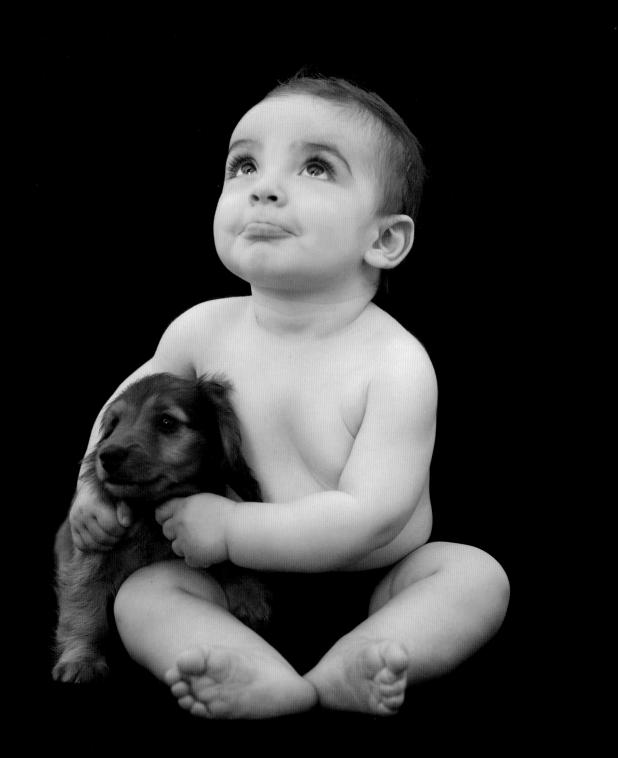

"Many people will walk in and out of your life,
but only true friends will leave

footprints in your heart."

—ELEANOR ROOSEVELT

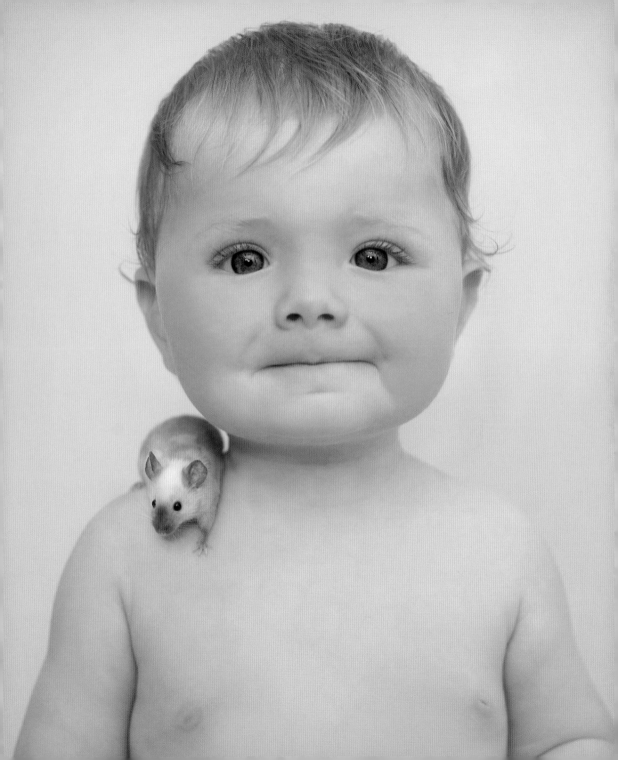

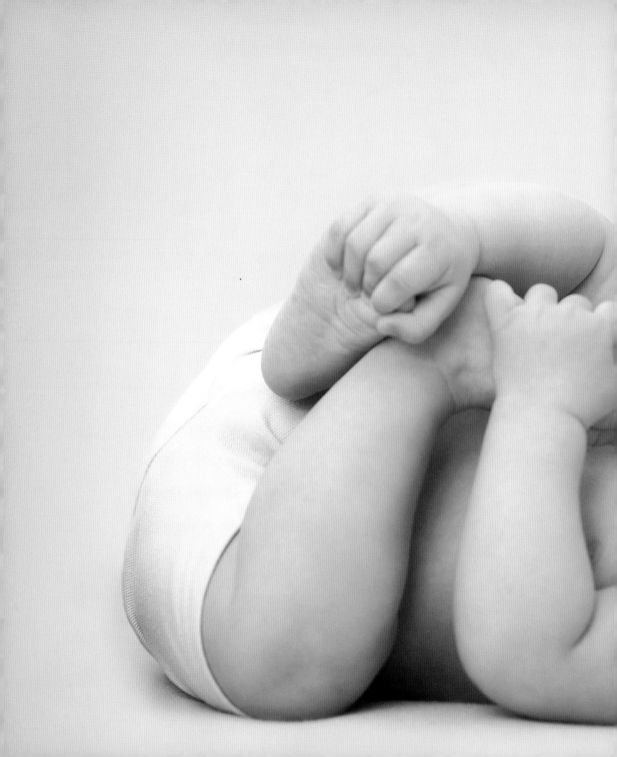

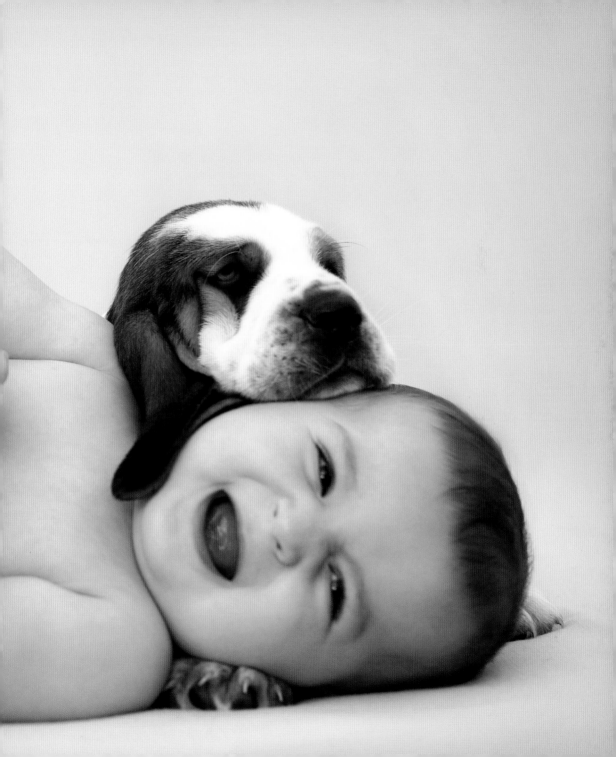

Even if you forget the punch line,
a best friend always laughs at your jokes.

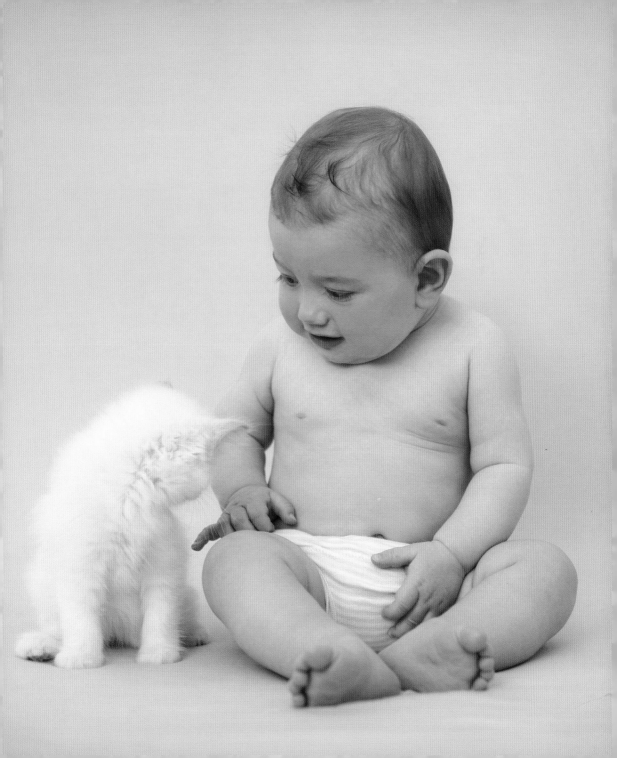

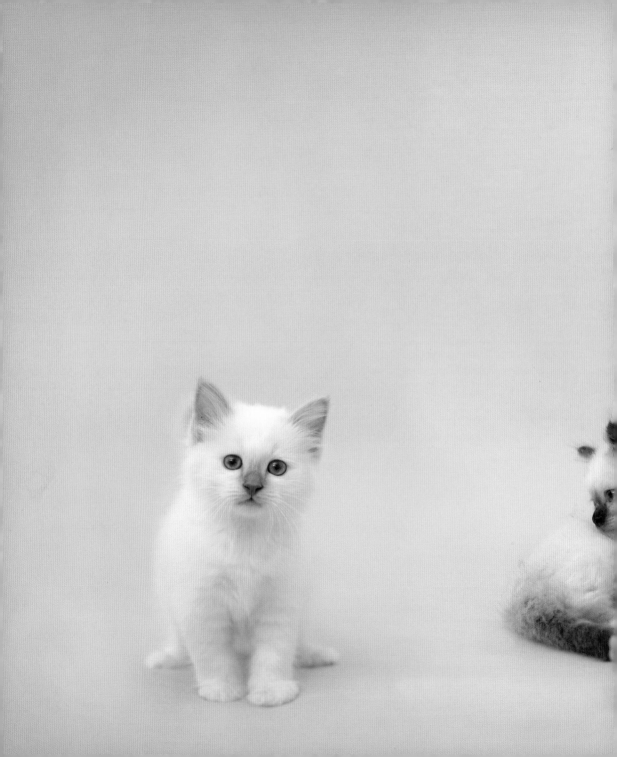

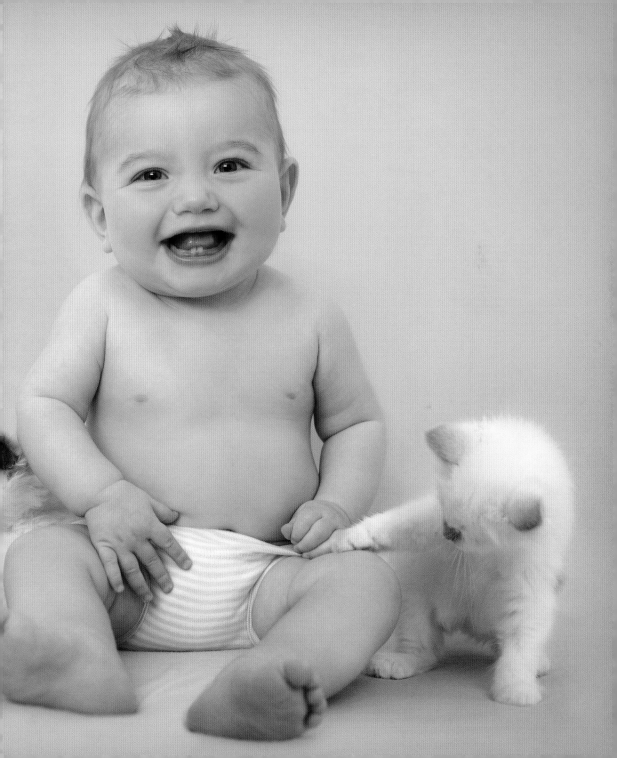

Good friends are like stars . . .

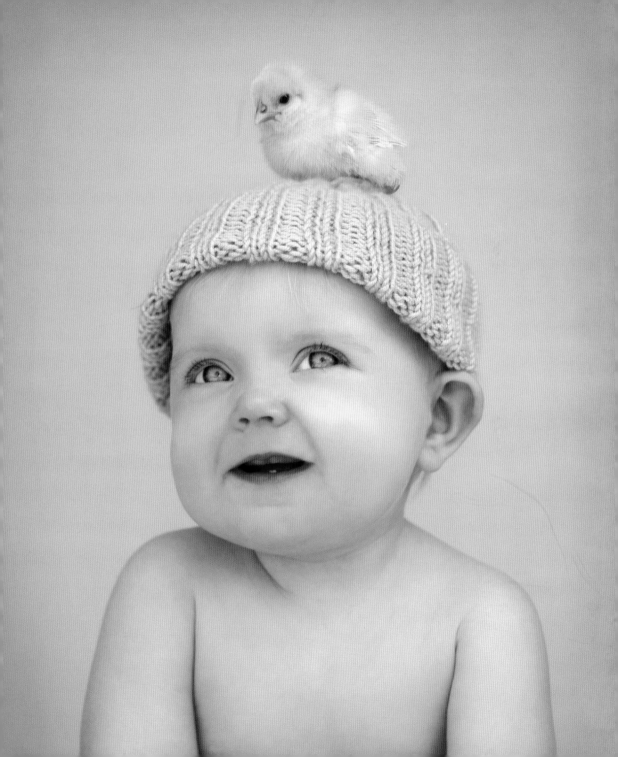

. . . you don't always see them,
but you know they are always there.

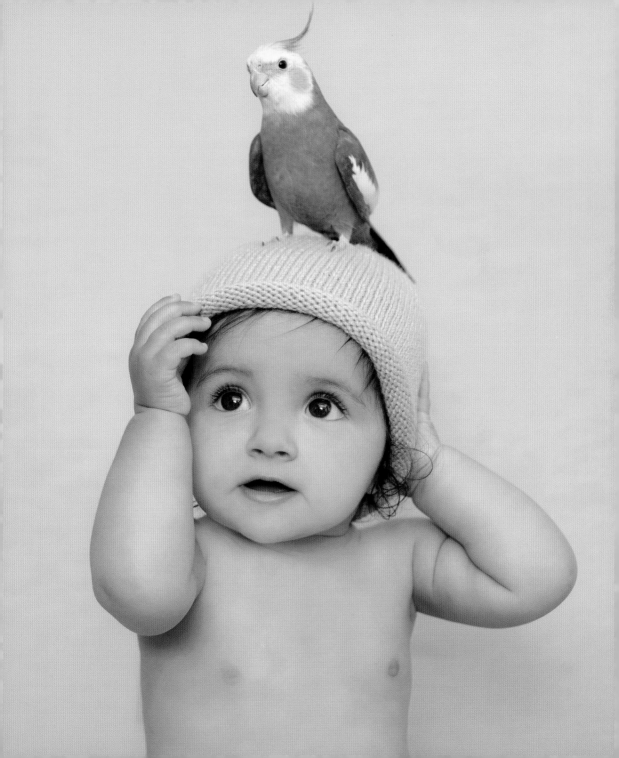

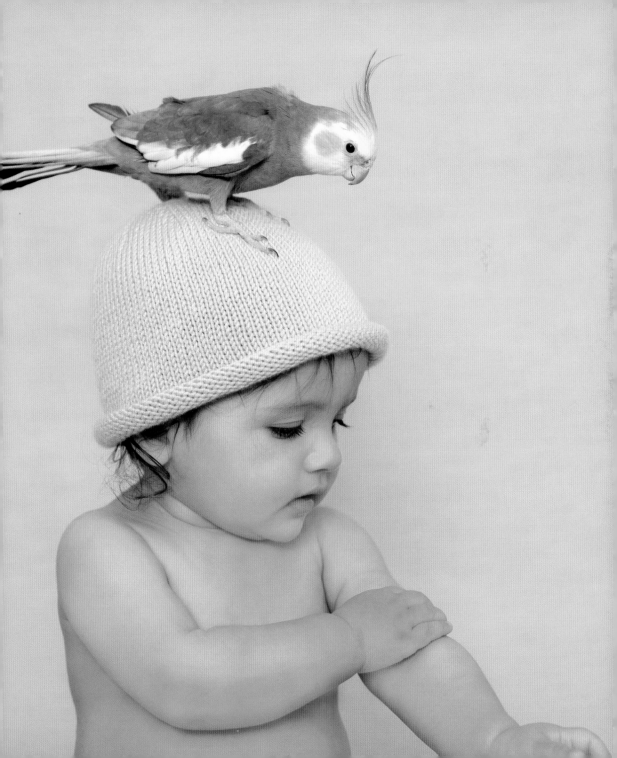

"Few delights can equal
the mere presence of someone
we utterly trust."

—GEORGE MACDONALD

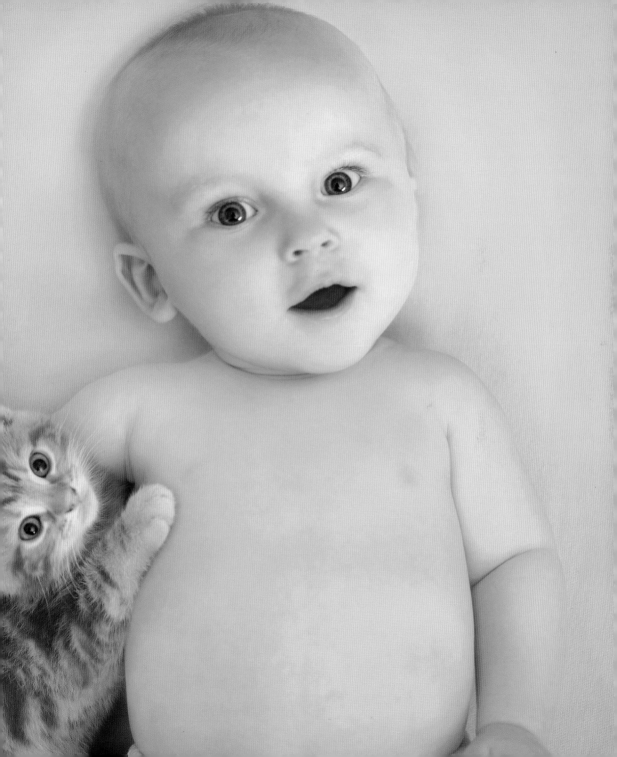

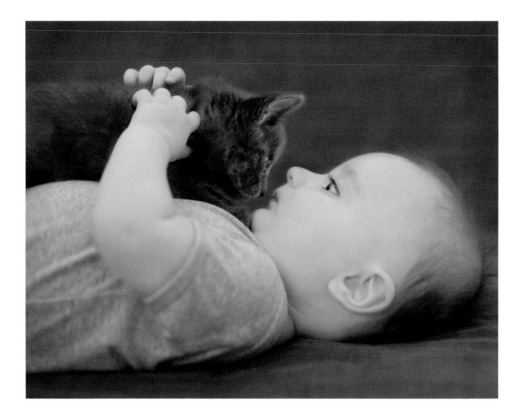

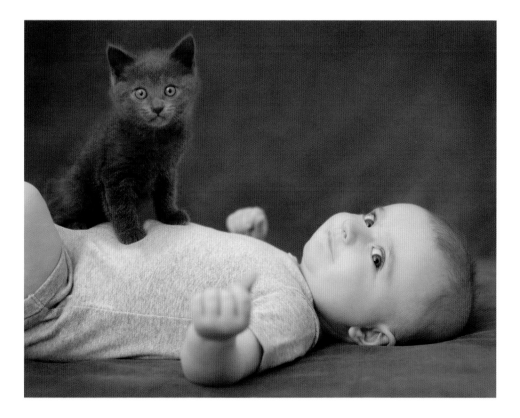

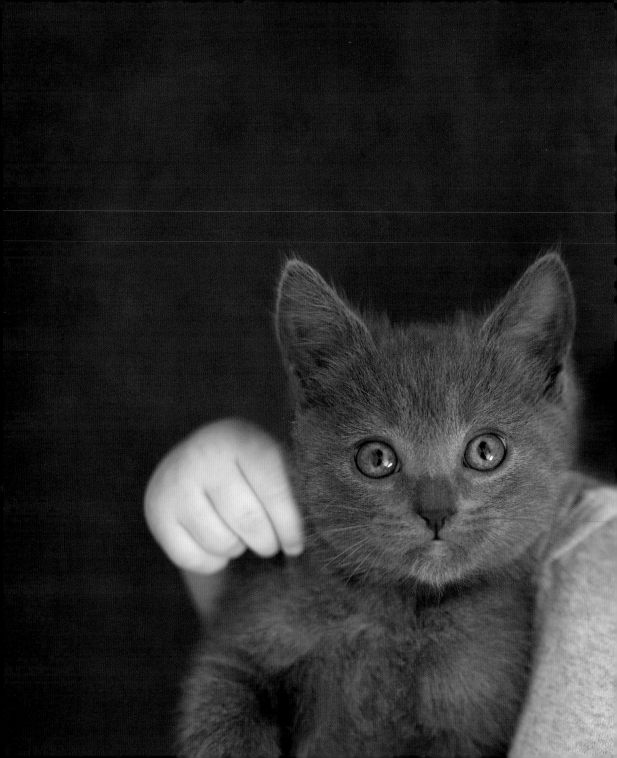

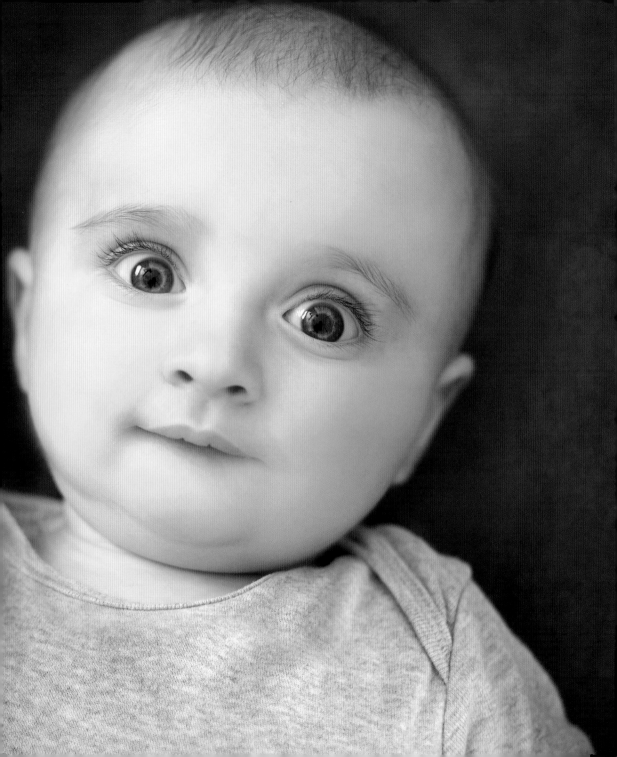

He has my back . . .

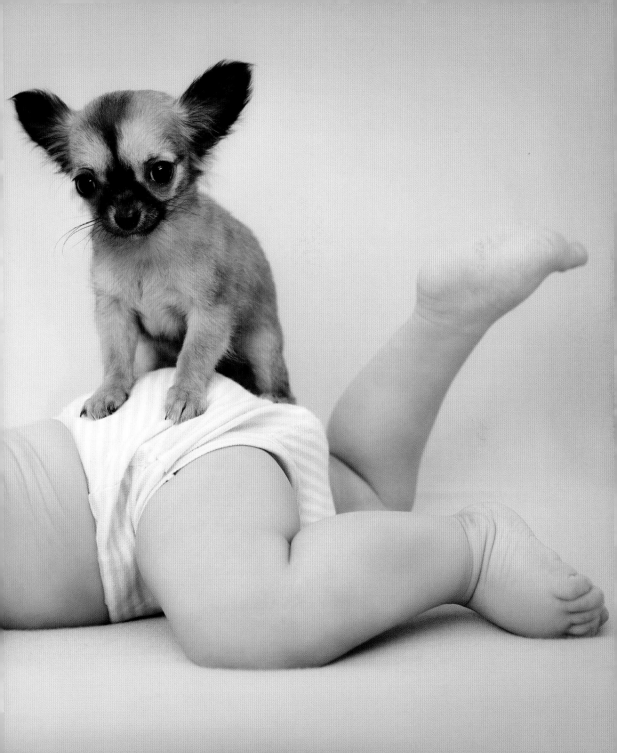

. . . and I have his.

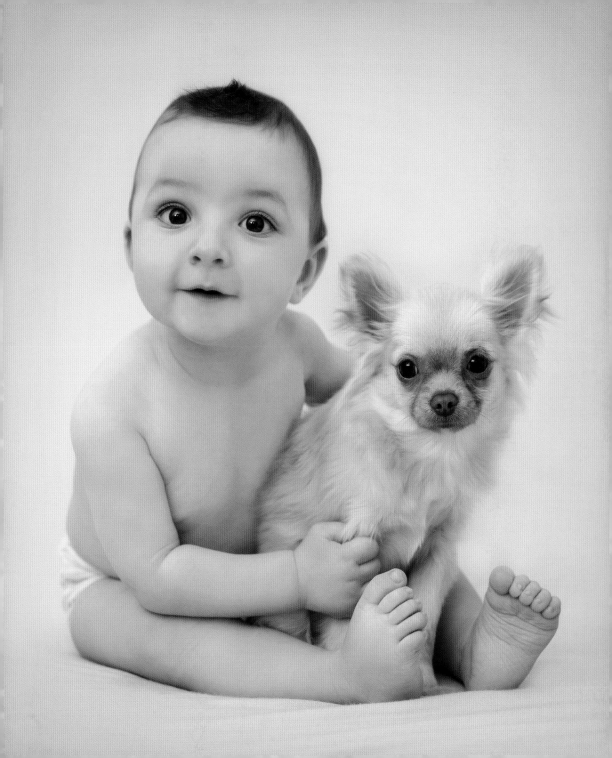

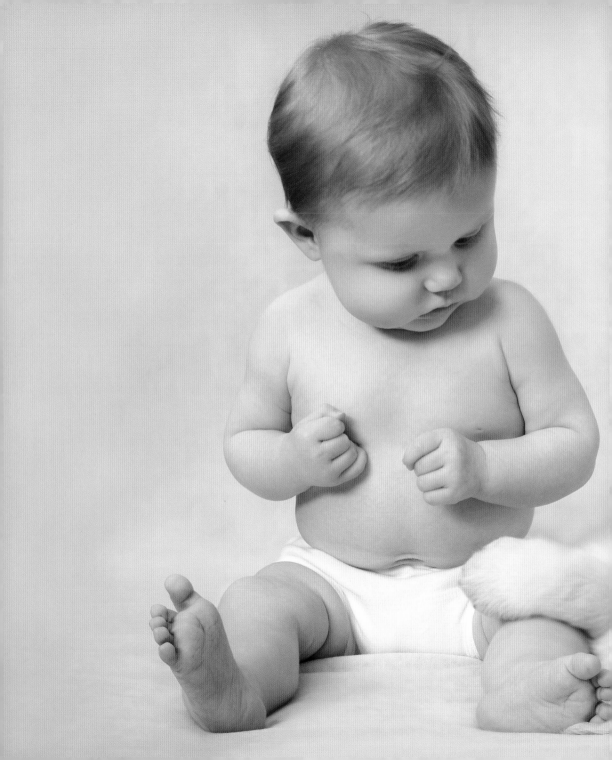

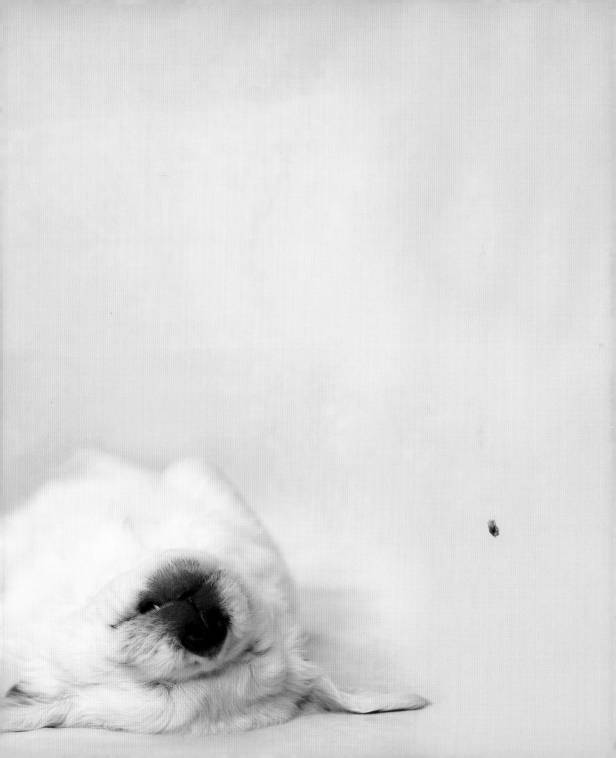

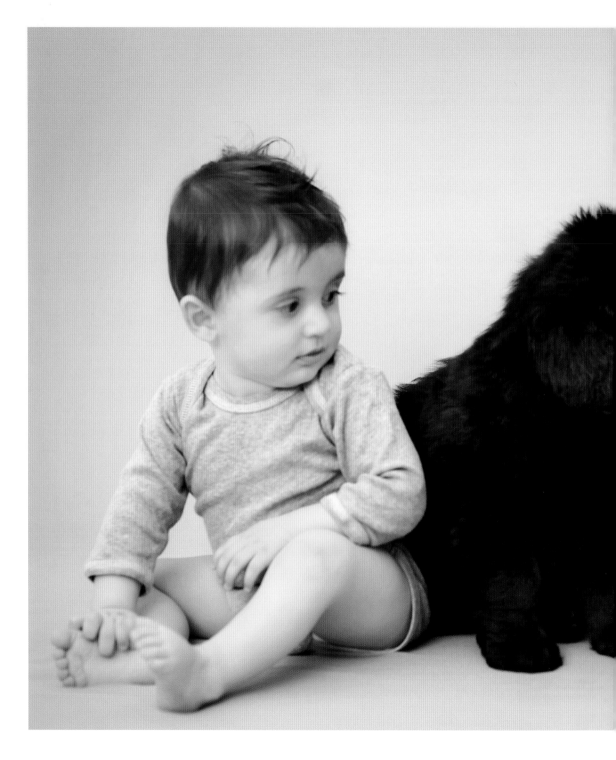

It's double the fun . . .

. . . with two.

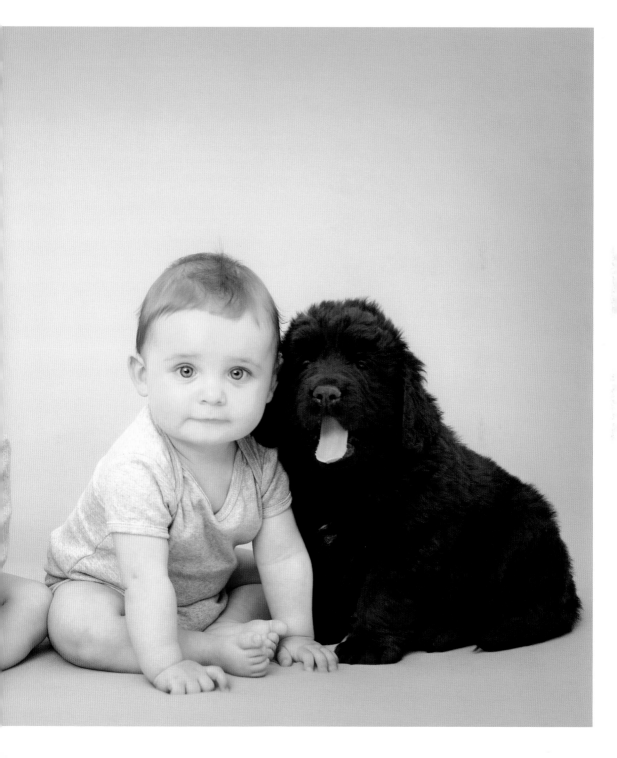

I like you just the way you are.

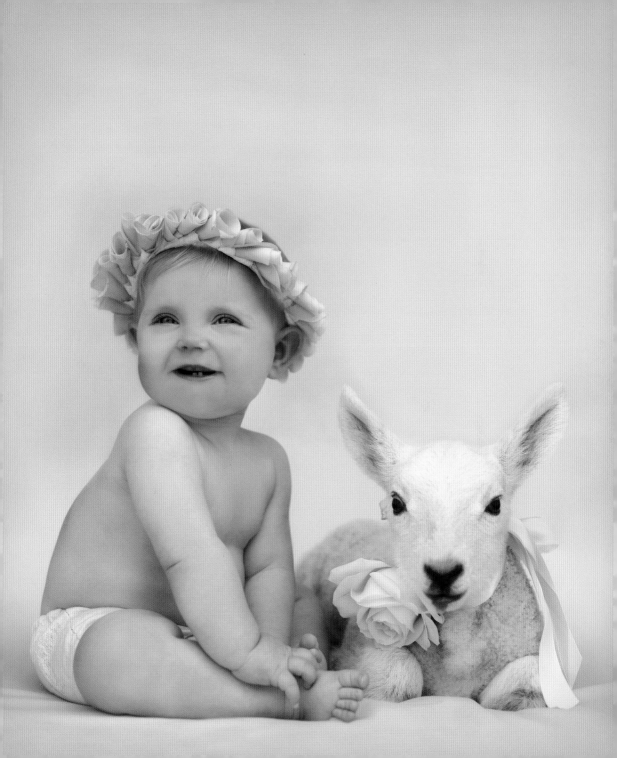

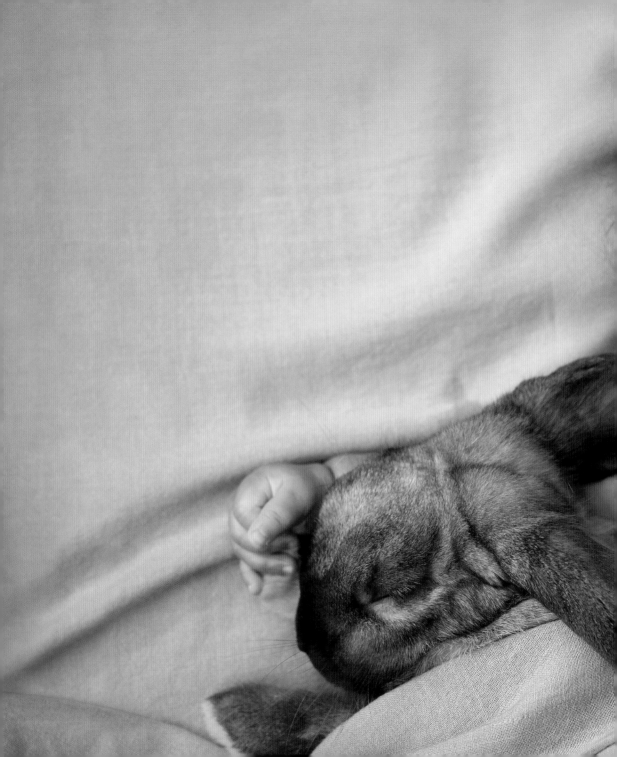

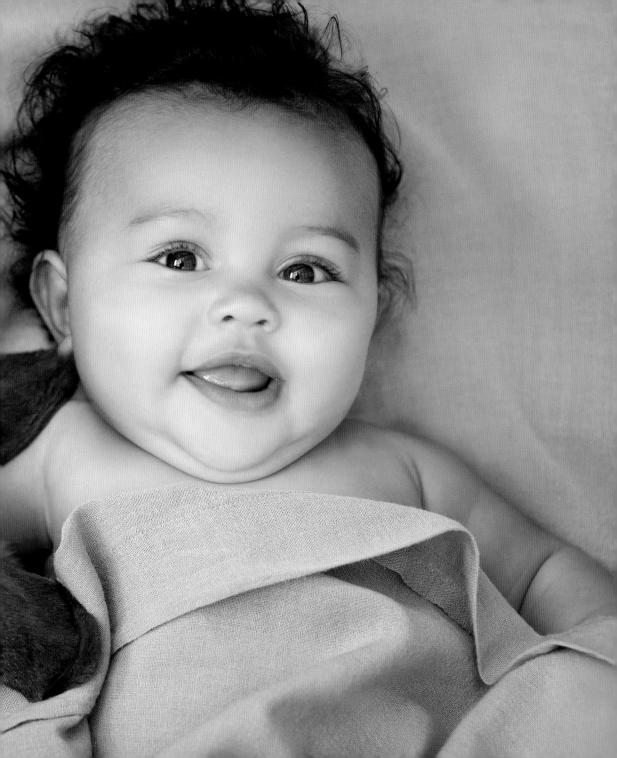

You plus me . . .

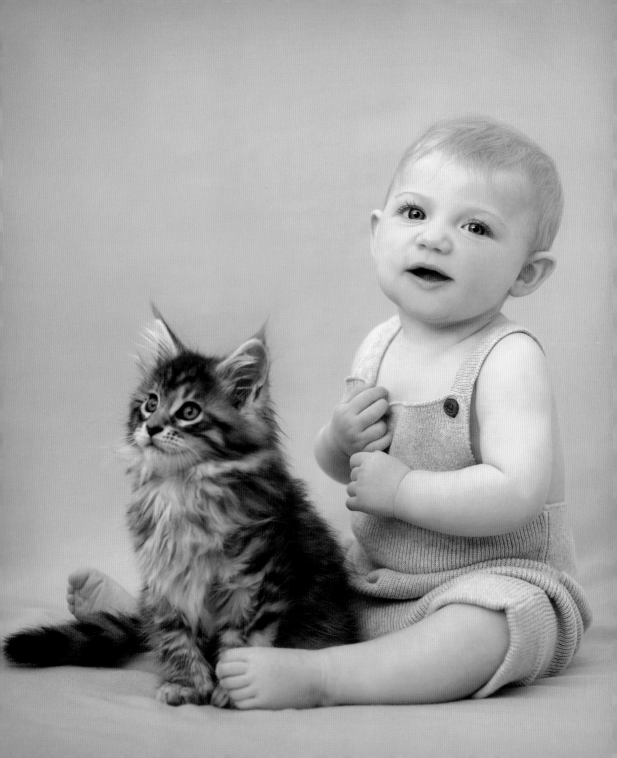

. . . equals fun to infinity!

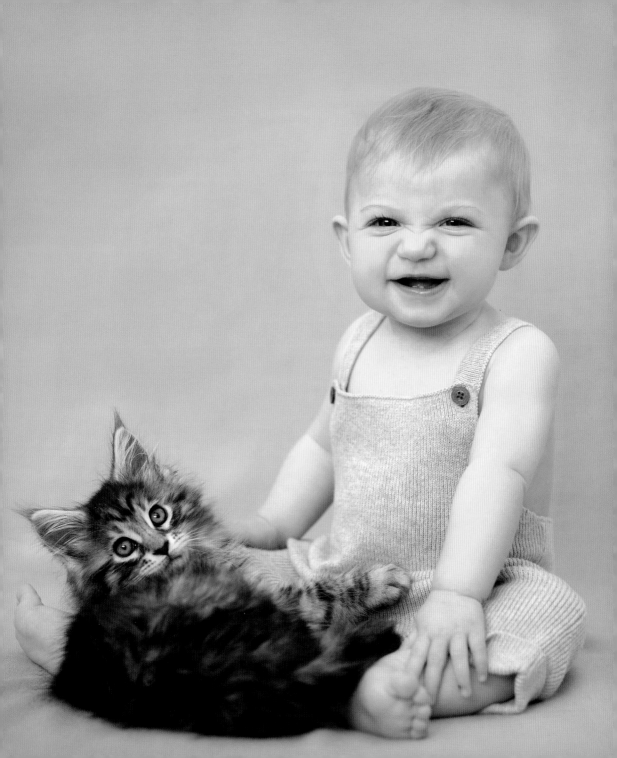

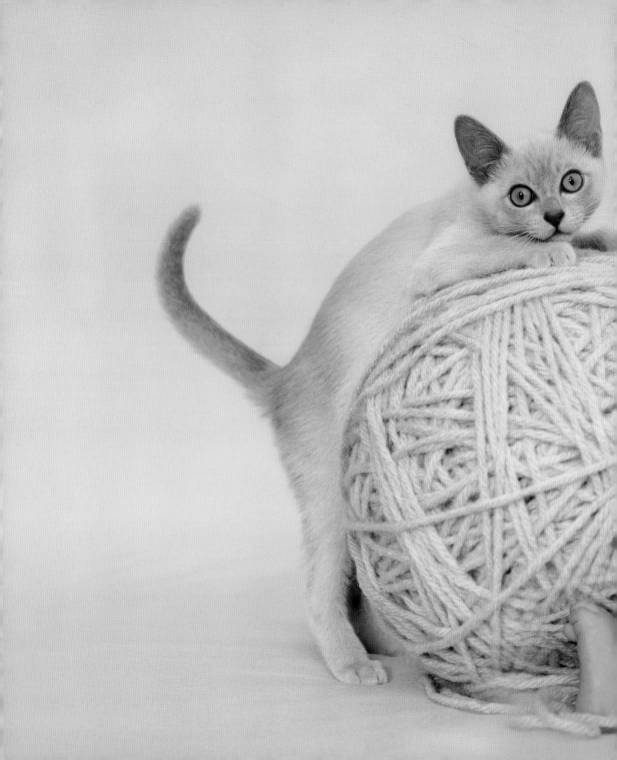

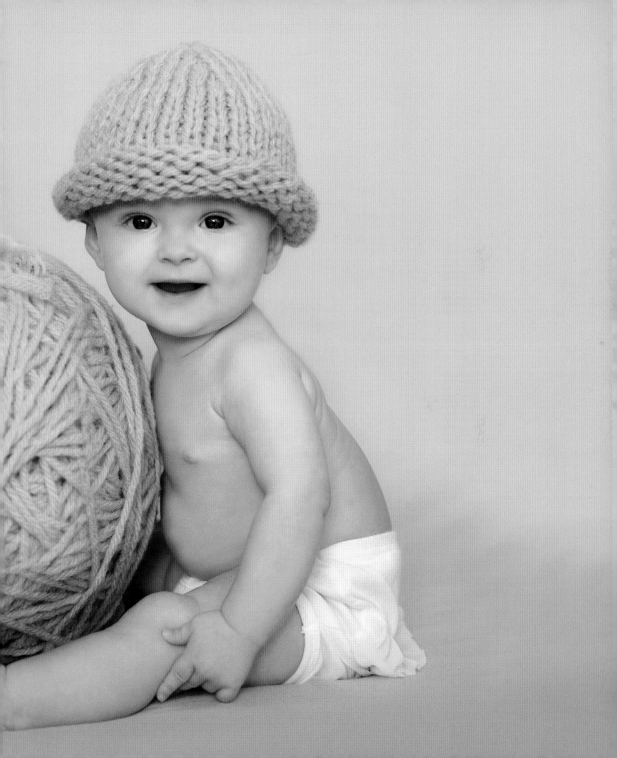

Just spending time with you
makes me happy.

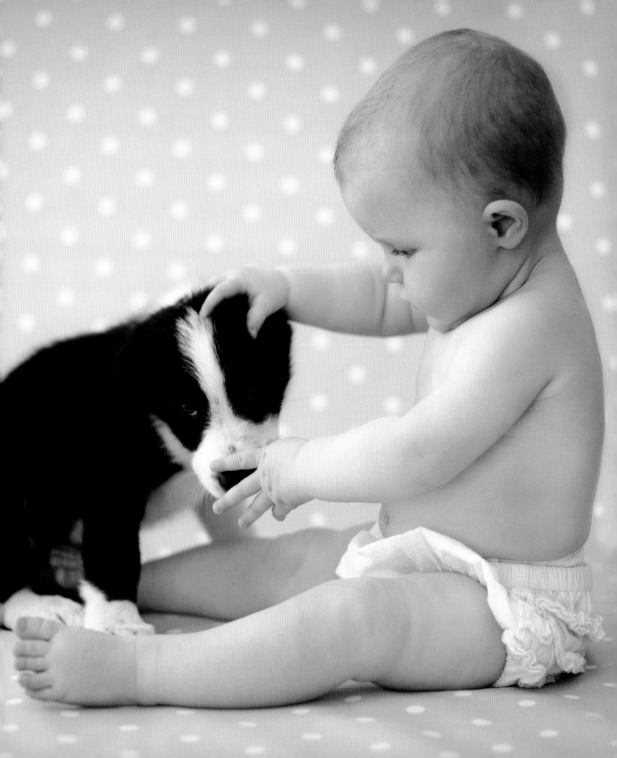

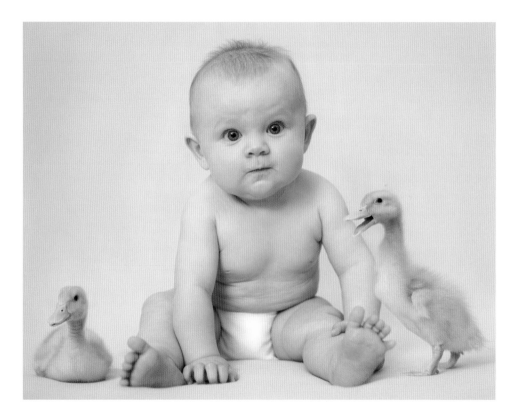

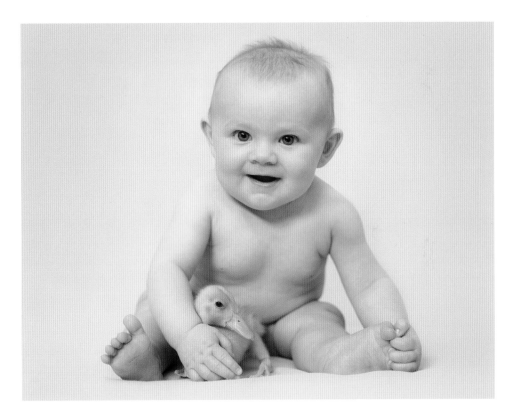

If you don't have

a smile . . .

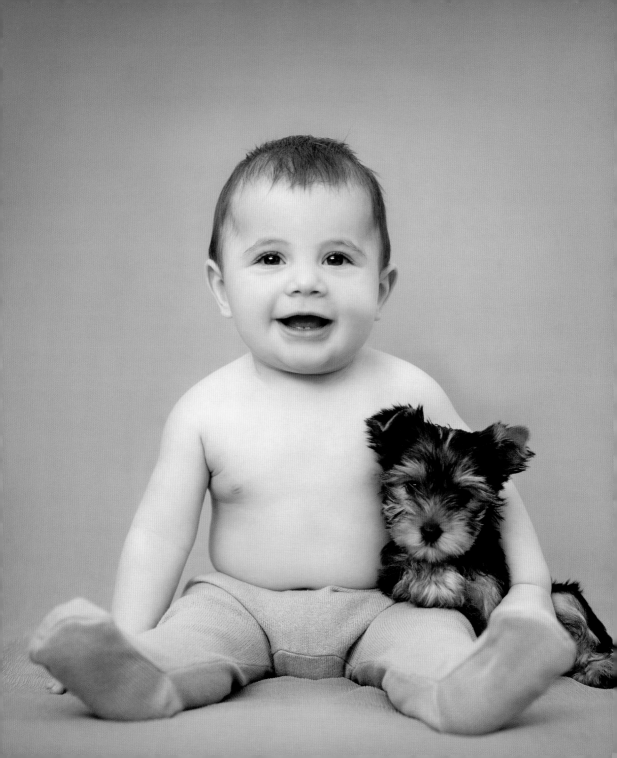

. . . I'll give you one of mine.

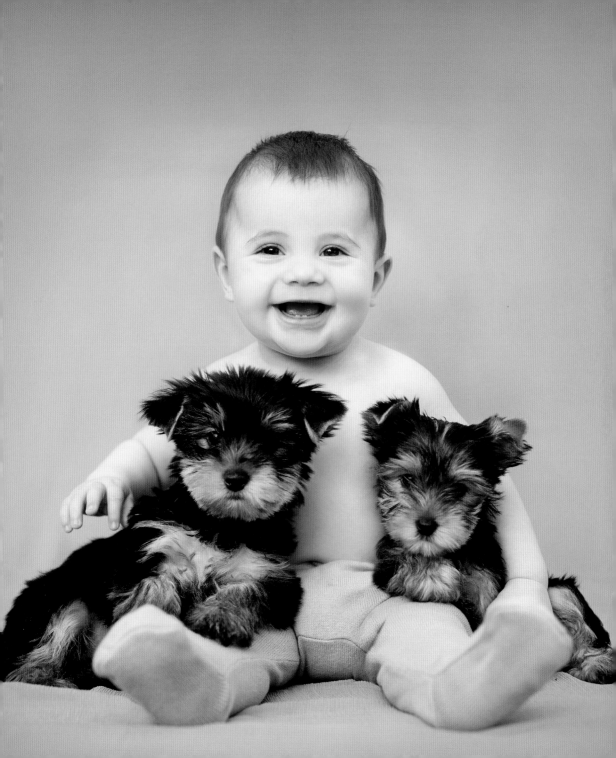

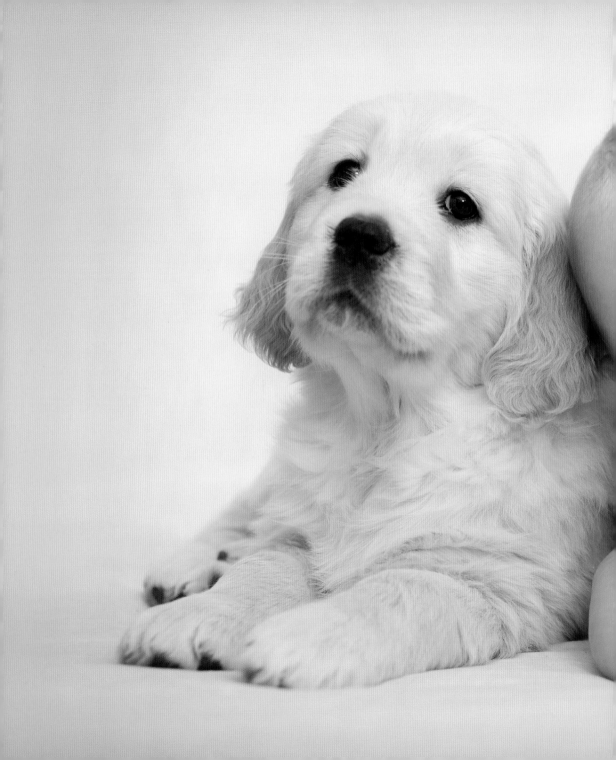

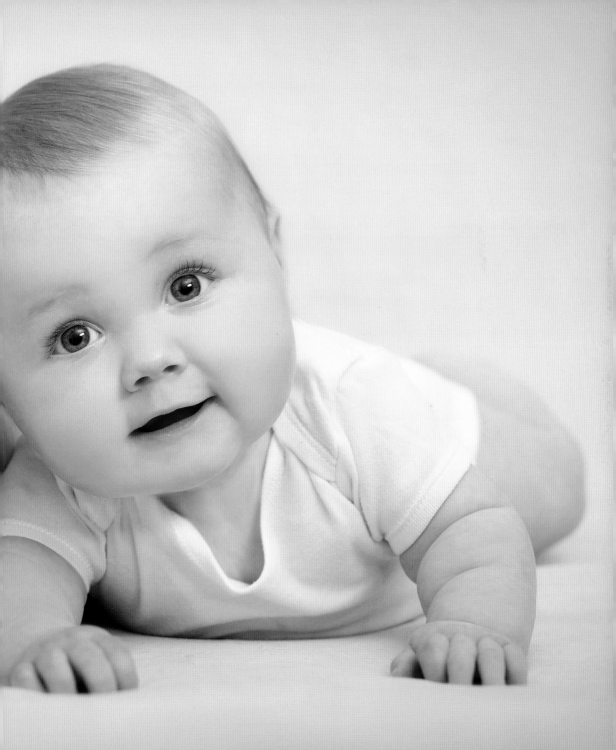

Best friends . . .

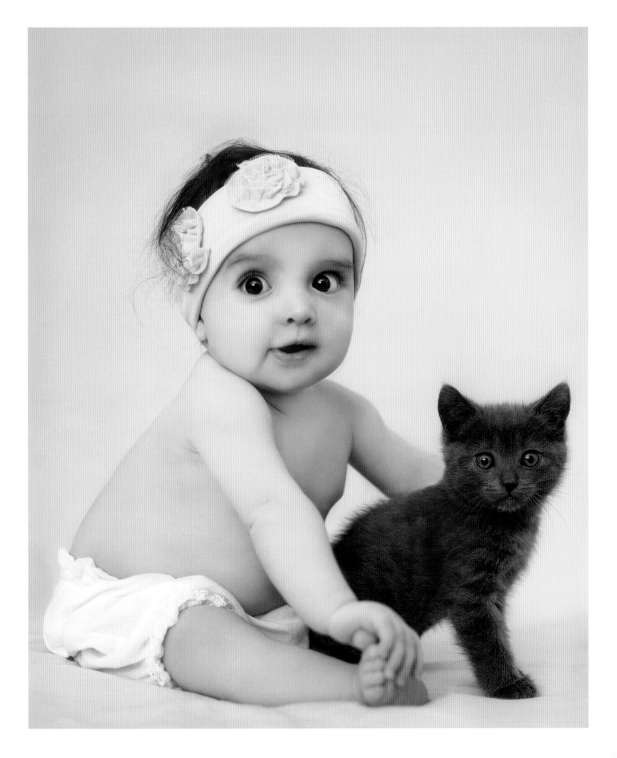

. . . are forever . . .

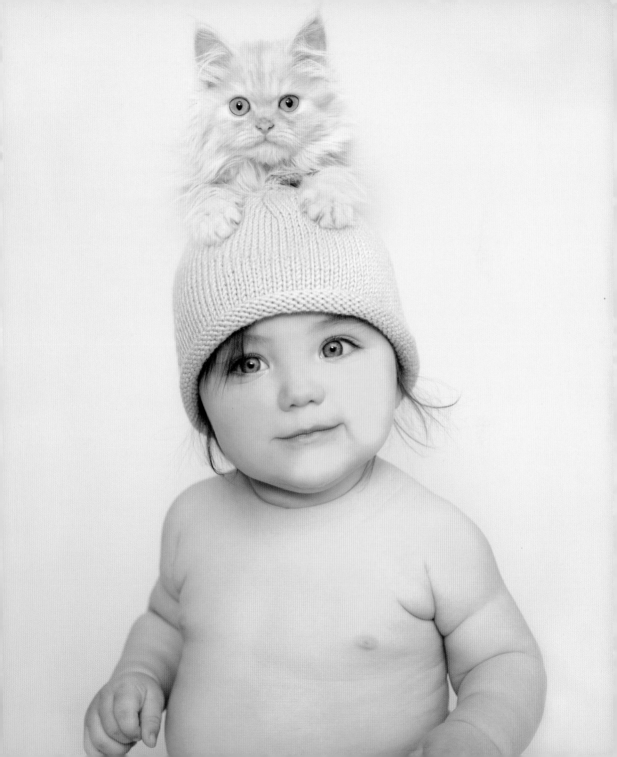

. . . and

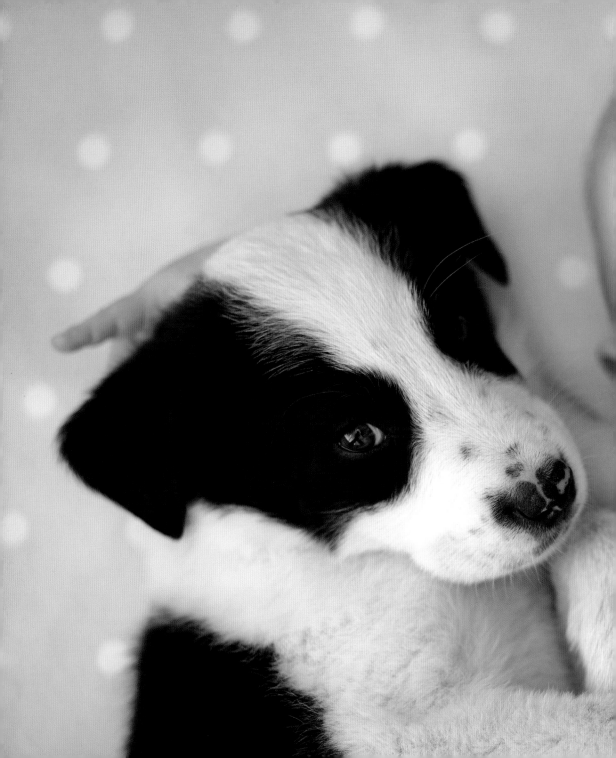

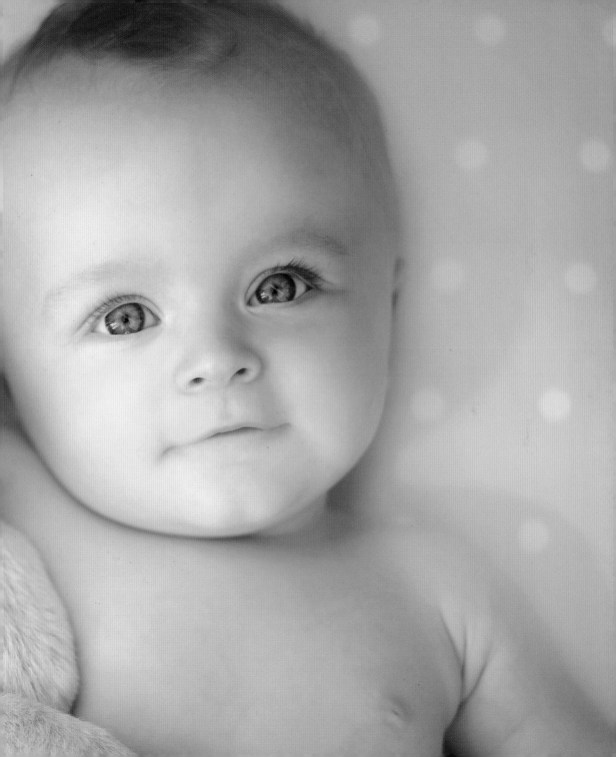

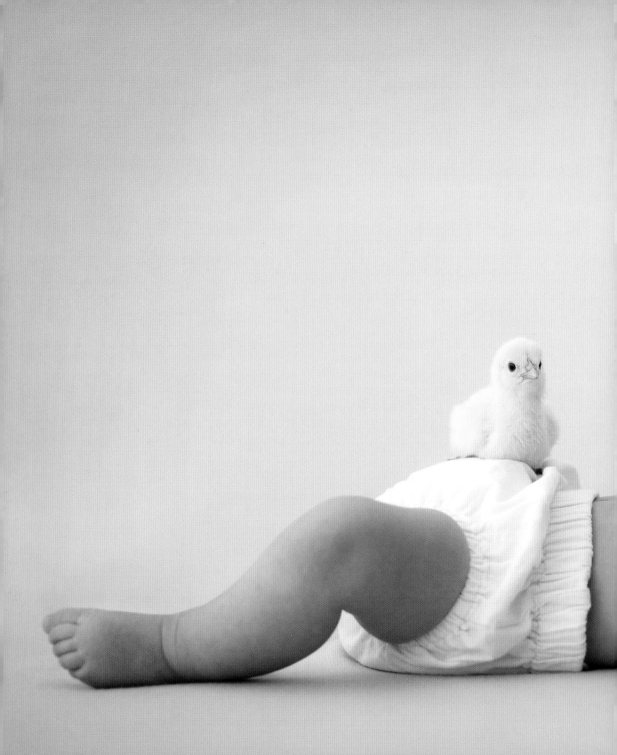

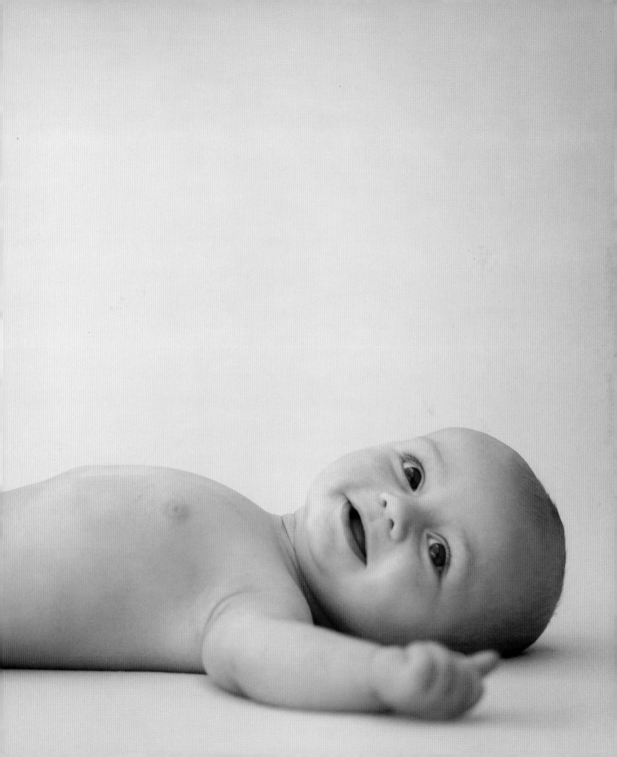

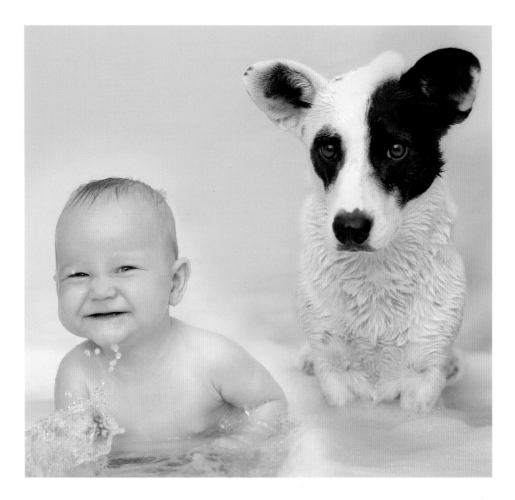

IN ORDER OF APPEARANCE

AND BEHIND THE SCENES

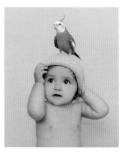
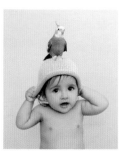
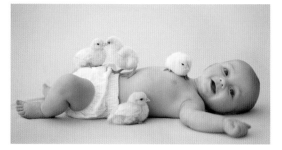

AANYA AND COCKATIEL

ALFIE AND CHICKS

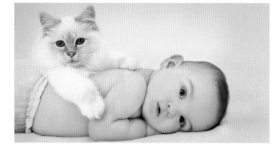
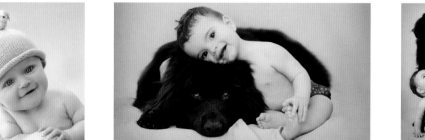
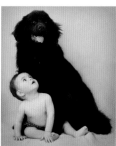

JOSHUA
AND CHICK

LOAN AND NEWFOUNDLAND DOG

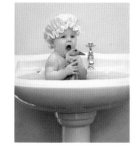

ALYSSA AND BIRMAN KITTEN (and endpapers)

LILY AND DUCKLING

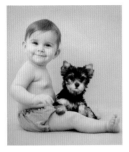
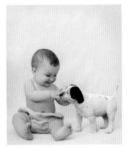
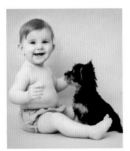
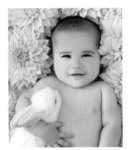

ERIN AND YORKSHIRE TERRIER PUPPY (and front cover)

YLAN AND JACK RUSSELL
TERRIER PUPPY

GRACE
AND DWARF RABBIT

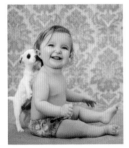
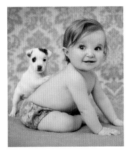
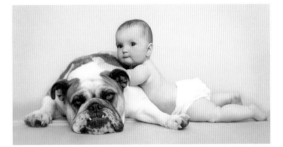

MAILYS AND JACK RUSSELL TERRIER PUPPY

NINA AND ENGLISH BULLDOG

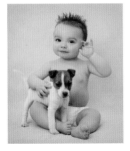
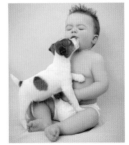
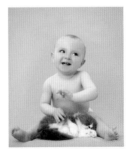
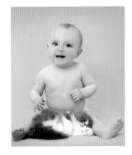

ENEO AND JACK RUSSELL TERRIER PUPPY

LOU AND PERSIAN KITTEN

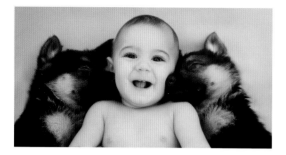

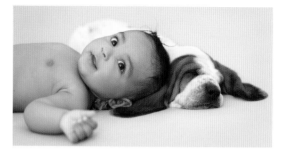

YANEL AND GERMAN SHEPHERD PUPPIES

LEONIE AND BASSET HOUND PUPPY

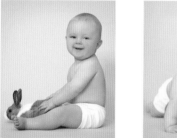

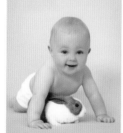

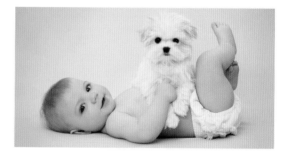

MASON AND DUTCH RABBIT

INES AND BICHON-MALTESE PUPPY

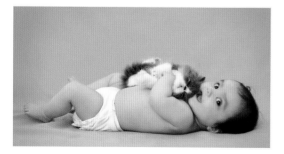

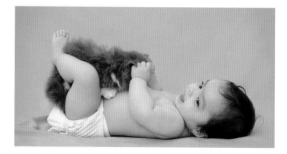

ELOISE AND PERSIAN KITTEN

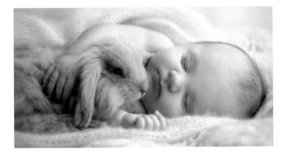

CHARLIZE AND DWARF ANGORA RABBIT

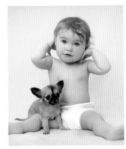

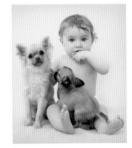

INAYA AND CHIHUAHUA PUPPIES

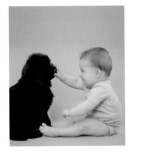

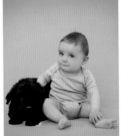

MARCEAU AND NEWFOUNDLAND PUPPY

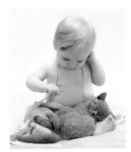

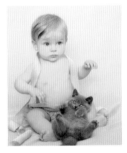

VIOLET AND BRITISH SHORTHAIR KITTEN

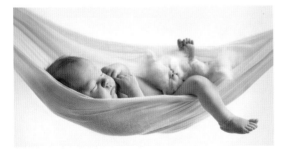

CHARLIZE AND PERSIAN KITTEN (and back cover)

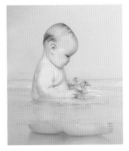

KATE
AND DUCKLING

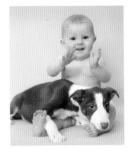

LILY AND RED BORDER
COLLIE PUPPY

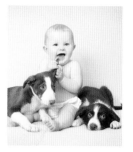

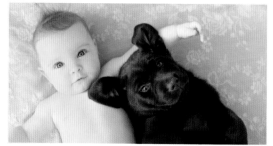

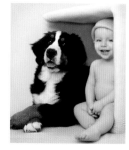

LILY AND RED BORDER
COLLIE PUPPIES

ALICE AND LABRADOR RETRIEVER PUPPY

NATHAN AND BERMESE
MOUNTAIN DOG

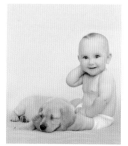

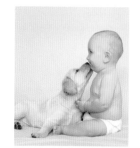

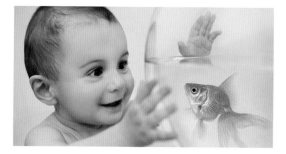

JACK AND LABRADOR RETRIEVER PUPPY

PAOLO AND FANTAIL GOLDFISH

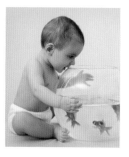

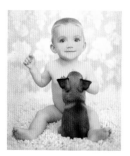

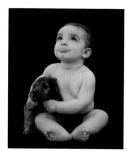

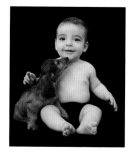

PAOLO AND
FANTAIL GOLDFISH

CHELSEA AND BELGIUM
GRIFFON PUPPY

LORENZO AND DACHSHUND PUPPY

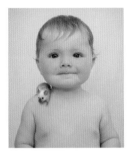

BAILEY
AND MOUSE

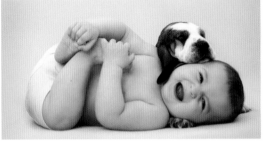

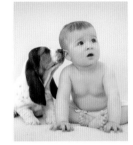

LORENZO AND BASSET HOUND PUPPY

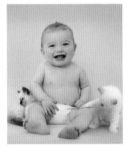

LUBIN AND
BIRMAN KITTENS

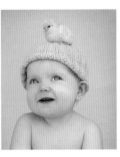

ISABELLA
AND CHICK

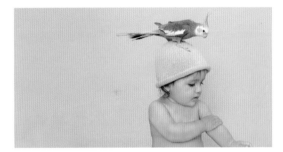

AANYA AND COCKATIEL

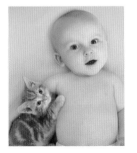

DERRY AND GINGER
TABBY KITTEN

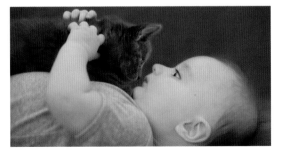

MAYLAN AND CHARTREUX KITTEN

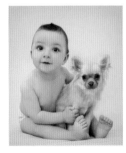

MILHAN AND
CHIHUAHUA PUPPY

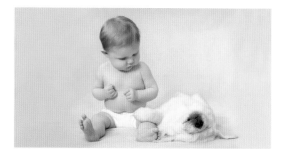

DIXIE AND GOLDEN RETRIEVER PUPPY

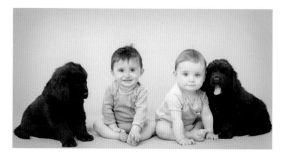

LOUISON AND MARCEAU AND NEWFOUNDLAND PUPPIES

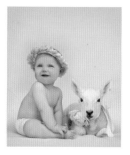

ISABELLA
AND LAMB

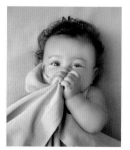

ANAHERA

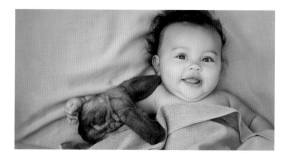

ANAHERA AND LOP RABBIT

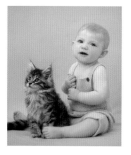

INES AND MAINE
COON KITTEN

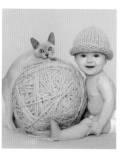

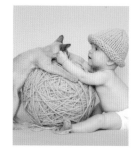

ZOE AND BURMESE KITTEN

LILY AND BORDER
COLLIE PUPPY

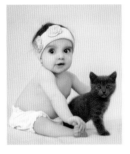

CHARLIZE AND DUCKLING

LUCAS AND YORKSHIRE
TERRIER PUPPY

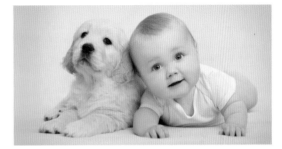

JOSHUA AND GOLDEN RETRIEVER PUPPY

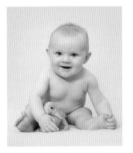

AALYAH AND
CHARTREUX KITTEN

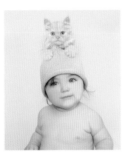

NINA AND HIGHLAND
VARIANT KITTEN

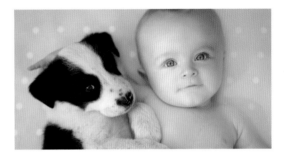

JOSHUA AND BORDER COLLIE PUPPY

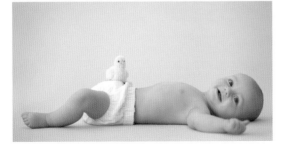

ALFIE AND CHICK

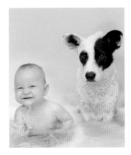

ABI AND
CORGI CROSS DOG

Rachael Hale McKenna is a world-renowned photographer and best-selling author. Her images have been published on greeting cards, calendars, posters, and stationery around the world, and her books, published under her maiden name, Rachael Hale, have sold more than 2.7 million copies in 20 languages. She lives in the South of France with her family.

Photograph by Andrew McKenna

First published in the United States in 2011 by Chronicle Books LLC.

Compilation copyright © 2011 PQ Blackwell Limited.
Images copyright © 2011 Rachael Hale Trust.

Every effort has been made to trace the sources of the quotes featured in this book, and the publisher apologizes for any unintentional omissions of acknowledgment. If any errors or omissions have occurred, corrections will be made in future printings.

Library of Congress Cataloging-in-Publication Data available.

ISBN: 978-1-4521-0102-6

Manufactured in China

Produced and originated by PQ Blackwell Limited
116 Symonds Street, Auckland, New Zealand
www.pqblackwell.com

10 9 8 7 6 5 4 3 2 1

Chronicle Books LLC
680 Second Street
San Francisco, CA 94107
www.chroniclebooks.com

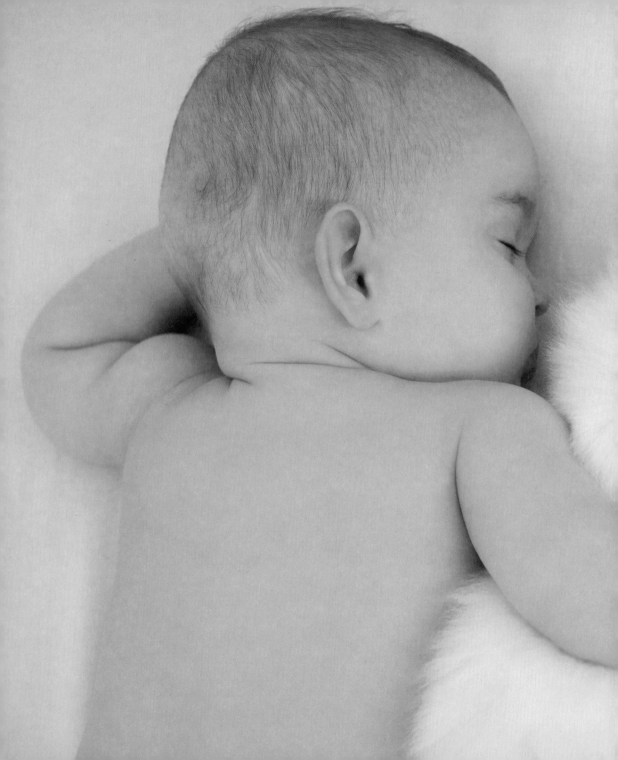